IMAGES
of America

HAWTHORNE

5/9/09

Dear Chris + Jill,

Congratulations on your New
Home. Hope its filled with

Love + Happiness!

Love
Phil + Donna

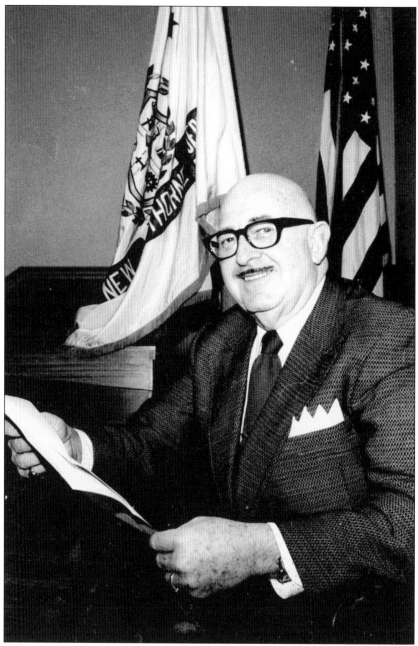

This book is dedicated to Mayor Louis Bay II (1912–2005), who, throughout his life, offered Hawthorne qualities such as vision and persistence.

Hawthorne has taken a proud place in the "march of progress" to a position where its citizens can look upon it with justifiable pride. It is our fervent prayer that, with God's help, we and our children, and our children's children, will pass on to the future a history which these future generations may look upon with the same pride of heritage.

—Louis Bay II, 1964

IMAGES
of America

HAWTHORNE

Don Everett Smith Jr.

ARCADIA

Published by Arcadia Publishing
Charleston SC, Chicago IL, Portsmouth NH, San Francisco CA

Printed in the United States of America

Library of Congress Catalog Card Number: 2005921535

For all general information contact Arcadia Publishing at:
Telephone 843-853-2070
Fax 843-853-0044
E-mail sales@arcadiapublishing.com
For customer service and orders:
Toll-Free 1-888-313-2665

Visit us on the Internet at http://www.arcadiapublishing.com

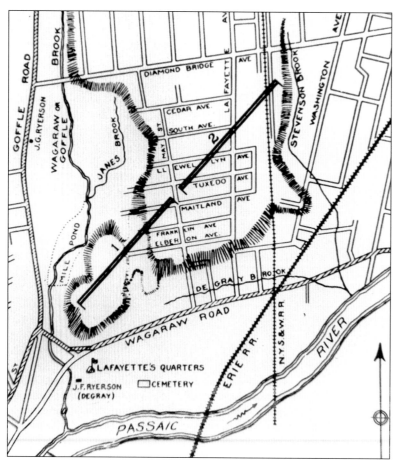

After years of European settlers and the rule of England, the colonists picked up arms and forced the crown of England out. This drawing was produced in 1964 to show where Brigade 1 and Brigade 2 were encamped in 1780. It was here that Major General Lafayette and the Light Corps set up camp to protect Gen. George Washington from a British sneak attack from the north or the east.

CONTENTS

FOREWORD

An old photograph, a newspaper clipping, a personal reminiscence—separately they may not seem like much, but combined they can define a community and provide a legacy for future generations. Books such as this one both acknowledge and honor those who have gone before us and preserve the memory of a time and way of life that is rapidly disappearing in suburban areas across the country.

In 1998, I was asked to collect and edit material for a 20th-century history of Rockland County, New York. I had already authored several books and articles on American history, specializing in the Civil War, and I admit that although the idea was interesting, the prospect of spending years working on local history was not very compelling. That attitude was to undergo a dramatic change.

I was born and raised in Rockland and began my career there as a research chemist. After 10 years in the lab, I turned to my real love: writing. I wrote about science and history, always focusing on other times and other places. Perhaps familiarity does breed contempt, because the thought of writing about local topics never crossed my mind. Having grown up with the people, places, and stories of the county, they did not seem to have the same importance as did people I had never met and places I had never been.

Then one day a man who had been a journalist in Rockland for 50 years called and suggested that I put together a 20th-century history of the county. Initially, I explored the possibility with little enthusiasm, but then the project slowly began to take hold of me. I met with local historians and lifelong residents who had marvelous facts and stories to share. I delved into boxes of photographs that had not seen the light of day for generations. The more I learned, the more I wanted to know. At the risk of sounding like Dorothy somewhere over the rainbow, I came to realize that there is no place like home and there is no more compelling history than that of the lives and events of your own hometown.

In the early years of the 21st century, Hawthorne faces the same challenges as countless other communities: how to wisely manage development while preserving the heritage of the past. It is a difficult problem as, in many cases, the historic structures are already gone. The influx of new people and new cultures has also brought an end to multigenerational families that once carried on traditions and memories from a community's earliest beginnings.

Yet there are people like contractor Henry Tuttman, who continues to work to restore the historic Van Winkle house on Goffle Road. He is restoring the 18th-century Dutch Colonial from the ground up, and in the process he is preserving the history of a family older than Hawthorne itself.

There are also the members of the Passaic County Historical Society who recognized the importance of collecting old photographs, newspaper clippings, and personal reminiscences, and Don Smith, who has taken the time to organize them into this wonderful book.

The importance of such a work is clear: the more people know about their town's past, the more likely they are to preserve it. Hopefully, this book will help future generations of Hawthorne residents understand and appreciate the individuals, organizations, places, and events that shaped the community in which they will live.

—Linda Zimmermann
Historian, Writer, Speaker

INTRODUCTION

Many of the amazing tales the world over have started with "Once upon a time" or "In the beginning" or, my personal favorite, "A long time ago in a galaxy far, far away." This story, however, begins with "One night in Nelke's Tavern . . ."

Hawthorne continued a long tradition of "breaking away and starting a life of its own." The tradition began when Europeans broke away from religious persecution and came over the sea to settle here. Next, the colonists broke away from English rule. Then, in 1837, Passaic County broke away from Bergen County and Essex County to become its own entity. Finally, in 1898, several men in Nelke's Tavern, on the corner of what it is now Rea Avenue and Goffle Road, decided that it was time they "broke away from Manchester Township and form our own."

That break was accomplished after a doctor named Sylvester Utter traveled to Trenton to "argue for independence of Hawthorne and North Paterson as a borough," according to Utter's grandson Donald Gray. Utter was then elected as the borough's first mayor in 1898.

Since that year, Hawthorne has grown from 500 people to nearly 18,000 residents. It is the perfect mix of towns, bridging the more urban municipalities of Paterson, Haledon, and Prospect Park with the more suburban towns of Glen Rock, Ridgewood, and Wyckoff.

Furthermore, it is crossed by highways such as Routes 208 and 20. Route 208 heads north to Wayne, Mahwah, or upstate New York and connects to Route 4, which goes east to New York City. Highway 20 joins the historical Wagaraw Road and leads into Route 80, which goes west all the way to San Francisco.

Although not named for any particular saint, as San Francisco was, Hawthorne was the given name of a train station in the 1860s (originally the station was called Norwood, but this led to confusion with the Bergen County town of that name), and so the borough became Hawthorne.

A long-standing question has been, "Where did the name Hawthorne come from?" One source claims it was from the hawthorn shrubs that farmers had to dig out of their fields. Another source says the town was named for famed New England author Nathaniel Hawthorne. However, we should dwell on what former U.S. representative Marge Roukema said in the House of Representatives in 1998: "The name is honored and revered and deserves the good reputation it has enjoyed for a century. It is one of the finest communities in our state."

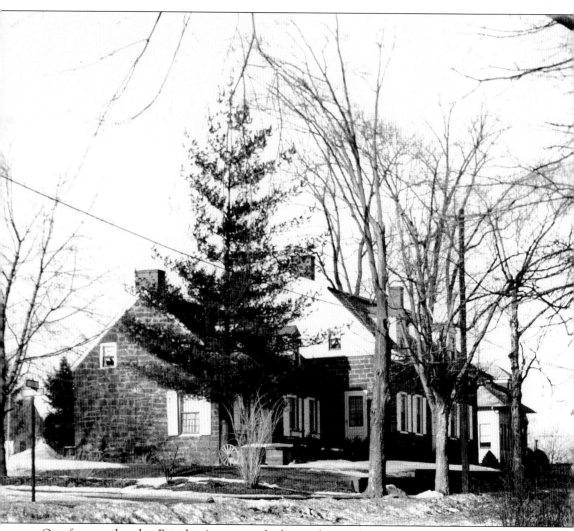

Out from under the British, Americans had to rule on their own and county and town governments were developed to do so. In 1837, Passaic County was formed. Just 13 years later, in January 1850, Judge John and Jane Van Winkle were murdered in their bed by former farmhand John Johnston. A native of Liverpool, England, Johnson was known to drink a lot, and it is believed that he was under the influence of liquor the night he committed the crime.

One

MANCHESTER AND EARLY HAWTHORNE

Some 15,000 years ago, a glacier cut a path through the northern part of what is now New Jersey and most of New York state. "The glacier scraped and scarred the hilltops and covered the rocky landscape with . . . rock and soil debris," local archaeologist Edward Lenik wrote in his 1999 book, *Indians in the Ramapos*. The ice "scoured the ridges leaving bare rock or a thin mantle of soil while valleys and side slopes . . . were filled with deposits of sand, gravel and boulders." In some places the deposits "blocked rivers and streams to form ponds, lakes and swamps." Later, after the glacier receded, trees took root in the fertile soil and the Leni Lenape and other Indians settled here, according to a Hawthorne 50th anniversary publication.

Lenape language specialist James Remeter recounts the Native American's daily life: "They were up with the sun . . . the women pounding corn and men preparing to hunt." After food, the most important things were family and home. The girl who got up early to pound the corn made "an ideal wife," Remeter said. Some of the homes were made of bark and covered with cattail mats, and others were log houses.

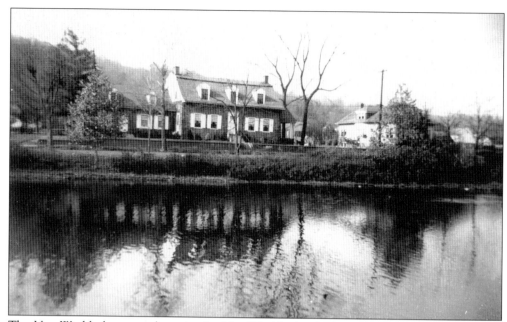

The Van Winkle homestead was in the Van Winkle family from the 1760s to around 1900. Dr. Claude Van Stone's family, however, also owned it for many years. Van Stone bought the homestead at auction from the town in 1942, and the house remained in the family until 2002, when his daughter Jean Brennan, sold it. It is now being restored.

This mortgage was found in 1852. The Van der Klucks, a well-known family, bought a piece of land in town on which to live, start a farm, and raise a family.

In 1898, in his first message as mayor, Sylvester Utter exhorted his newly elected council and board to "start aright and keep aright and hand down to our successors in office such an example that they cannot help but appreciate and will honestly try to emulate."

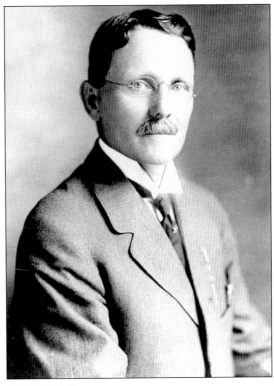

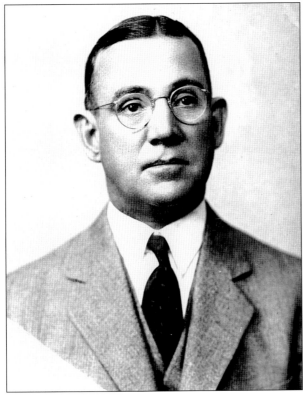

Arthur Rhodes was first elected mayor of Hawthorne in 1916. He, Thomas Jowett, and John Houmann were elected commissioners in 1931 for a four-year term and were then called Hawthorne's "Big Three." Rhodes died of pneumonia in 1936.

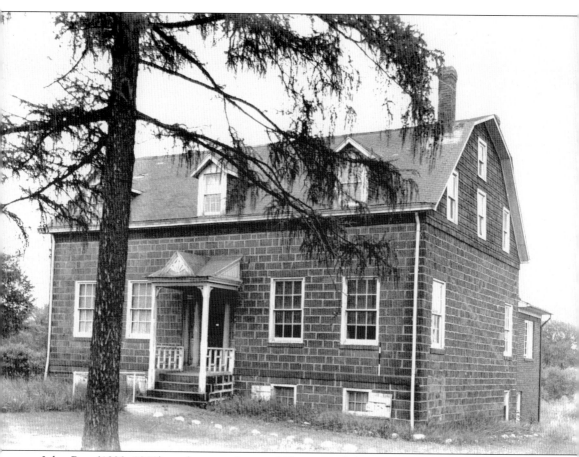

John Rea (1823–1900) used to travel around Europe and the United States under the name John W. "Jack" Raynor. He was a manager and co-owner of the Christy Minstrels. Later in life, he served as superintendent of schools when Hawthorne was still called Manchester. He was often referred to as "Squire Rea" after becoming a justice of the peace. The Rea house sits on Goffle Road near the corner of Rea Avenue. It eventually became a tavern, and decades before it was converted into the town senior center, it was a boys' club. Later, a boys' and girls' club was built on Maitland Avenue.

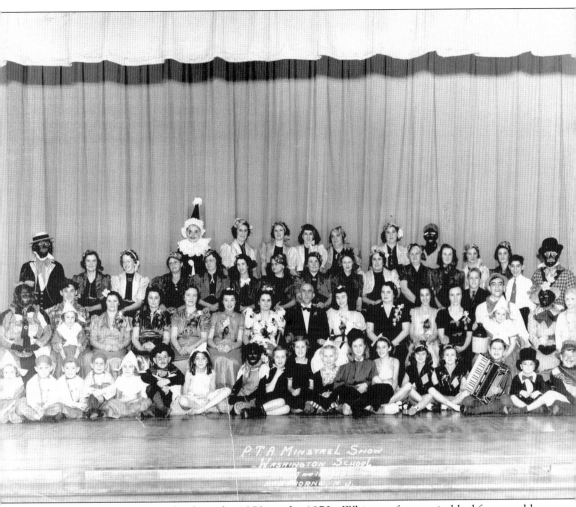

Minstrel shows were popular from the 1850s to the 1870s. White performers in blackface would sing and dance in an exaggerated manner, portraying African American slaves. These "parodies helped shape society's perceptions of African-Americans—and of women—and made their mark on national identity, policy making decisions and other forms of entertainment such as vaudeville, burlesque, the revue, and, eventually, film, radio, and television," states a report by historical preservationists John Lacz and Mary Delaney Krugman. This photograph was taken in November 1938 for a Parent Teachers Association Minstrel Show at the Washington School.

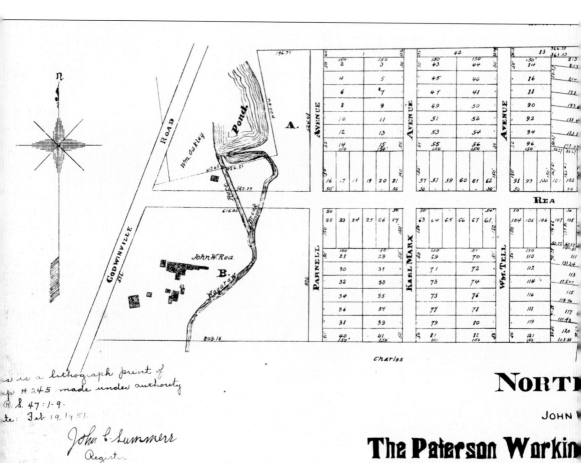

NORTH

JOHN W

The Paterson Workin

What is little known about John Rea is that he wanted to name the roads surrounding his homestead (now First Avenue, Second Avenue, Third Avenue, and so on) after "heroes from

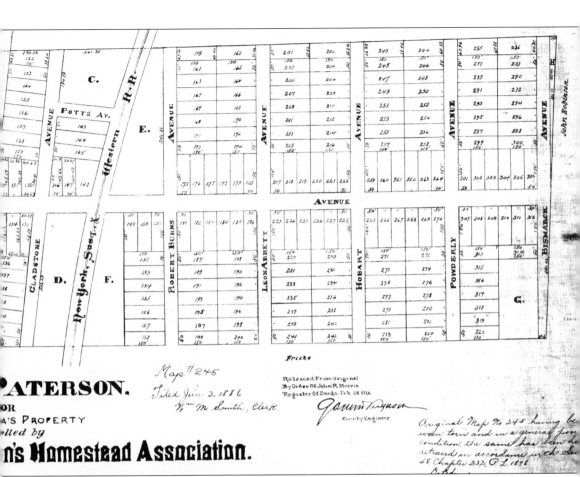

PATERSON.

OR

A'S PROPERTY

lled by

n's Homestead Association.

the labor movement"—Karl Marx, Charles Parnell, Terence Powderly, and legendary Swiss archer William Tell.

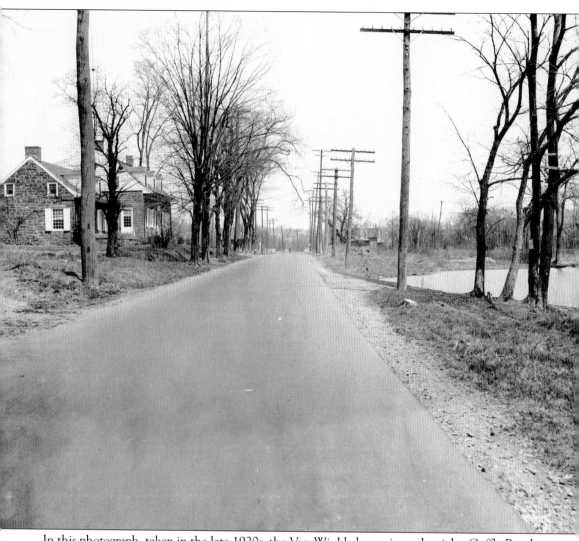

In this photograph, taken in the late 1920s, the Van Winkle house is on the right. Goffle Brook Pond, at one time called the Arnold Pond, is in the middle. The pond and waterfall were used by the Van Winkles for a gristmill. On the right is a 1928 Chevrolet heading down Van Winkle

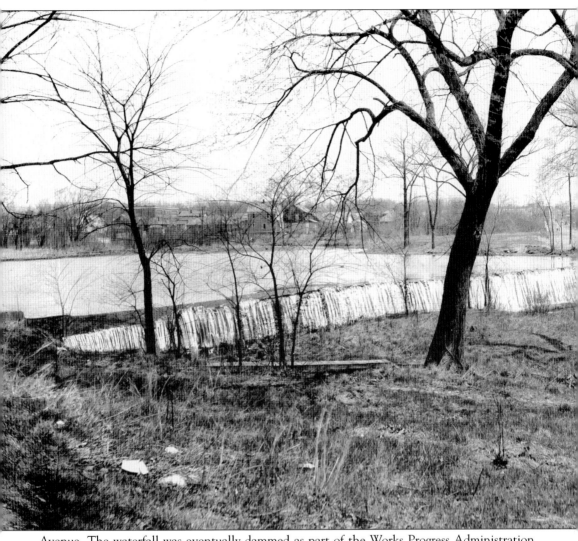

Avenue. The waterfall was eventually dammed as part of the Works Progress Administration (WPA)—projects initiated in the 1930s Depression years by Pres. Franklin Delano Roosevelt.

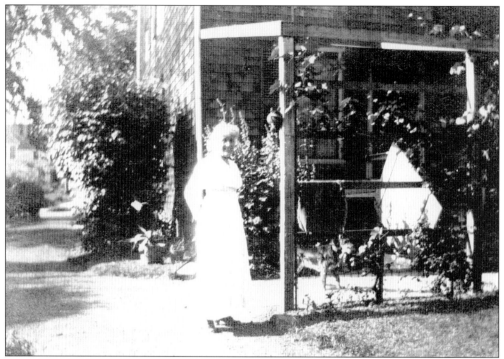

This home is located at 164 Diamond Bridge Avenue. Bessie Lucas stands there smiling. She is a wife, mother, and a homemaker back in the day when it was common for women to stay at home and manage their household.

The Lucas family owned this home for several years. Note that the driveway is not paved. Dirt driveways were common in the Diamond Bridge Avenue area.

Two

RESIDENTS

In 1948, Mayor Louis Bay II wrote a proclamation celebrating Hawthorne's 50th anniversary. In it he said, "Other heads of municipalities may preside over larger areas or populations, but none have the honor which is mine of serving a borough inhabited by people so charmingly constituted that they uniquely blend a progressive, urban outlook with a neighborly, suburban friendliness—a supreme achievement indeed, testifying to the fine spirit and the rare qualities of the citizens of the Borough of Hawthorne."

This chapter contains the average everyday images of Hawthorne citizens from the last 100 years.

This house on Diamond Bridge Avenue is no longer there. In its place is an apartment complex, one of several on that street. Two apartment buildings are now on the lower part of Lafayette Avenue and in certain other parts of the town. The economic advantages of New York City and Paterson brought many new residents to Hawthorne.

Here is another shot of 164 Diamond Bridge Avenue. Looking out from the driveway in the early 1920s and 1930s, one could see cornfields. Today, the area is all homes and neighborhoods.

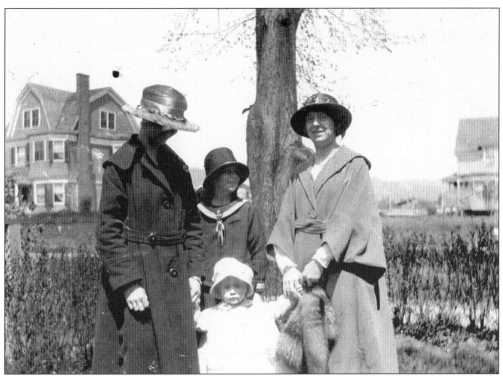

This photograph was taken at the end of the drive at 164 Diamond Bridge Avenue. Pictured are Ida Chase, Elsie Reuchenlach, Alice Lucas, and little Joan Lucas. They were enjoying a nice day.

This is the Lucas family dog. Although his name has been forgotten, he no doubt was loved by the family, as proven by this photograph. The hand in the photograph is that of Bessie Lucas's husband, William Lucas, trying to pose the dog.

William Lucas finally gets the family dog to pose right by holding the leash while standing in front of the family's wood-shingled home. This style of home was popular in the 1920s and 1930s.

Bessie Lucas, formerly Bessie Johnson, works in her garden. The wooden bucket on the stump was something in which the Lucas family grew flowers and other plants.

This photograph shows William and Bessie Lucas posing in their backyard at 164 Diamond Bridge Avenue. Proving their love for the canines of the world, here they are with another family dog. Sadly, the name of this dog, like the other, is lost to history.

Tom Malcolm stands with William Post's cow in the early 1920s. William Post was one of the first town assessors. In the background, the house in the center belonged to the Van Stones. The Van Stones were also a prominent family through the middle of the 20th century. They served in many capacities in Hawthorne's education system.

A friend of Tom Malcolm sits in front of the LaFavorite Rubber factory in the early 1900s. The factory was located in Hawthorne and was a source of jobs for many of the residents in town.

This tintype shows a Hawthorne family. Tin was a popular backing for photographs of the day, and this particular photograph was in the possession of Judy Magna, writer and director of the video *Hawthorne's Journey to Its Centennial.*

Guion Whitaker, pictured around 1917, served in the American military during World War I. The rifle he is holding is a Springfield M1917. This rifle compared well to its British counterpart, the Lee Enfield (named for inventor David Lee and place of production, Enfield, England).

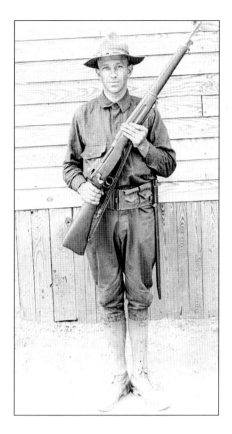

During World War I, Pres. Woodrow Wilson said in an address to the nation, "The industrial forces of the country, men and women alike, will be a great national, a great international service army—a notable and honoured host engaged in the service of the nation and the world, the efficient friends and saviours of free men everywhere."

Guion Whitaker was one of those "saviours of free men everywhere." In honor of those men, a World War I memorial was erected in front of the municipal building on Lafayette Avenue. And because of his service, Whitaker's name is mentioned on the World War I Honor Roll and Memorial outside of the municipal building.

William C. Johnson is the only known person from the town of Hawthorne to die in the sinking of the *Titanic*. Frank Trunquist told Johnson's father that "There was no one like Billy," and that he was a "fellow anyone would like." Johnson served as a cadet (right) and later as a fourth quarter master on the S.S. *Philadelphia*. The *Titanic's* Captain Smith liked Johnson, called him "Kid," and often joked around with him. As the ship was sinking, Smith told Johnson to get on a lifeboat, but Johnson refused, saying, "I'll wait until the women and children are all off." Smith responded, "You're made of the right goods, Kid."

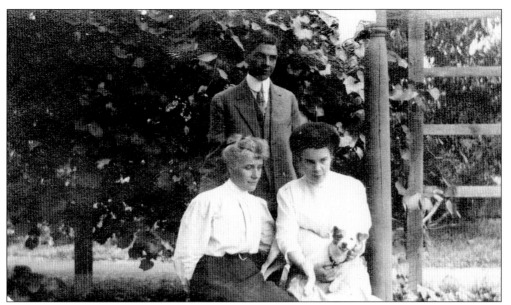

William Johnson poses with his sister, Bessie Lucas (right), at her home on Diamond Bridge Avenue and with a family friend and a dog. Johnson consistently wrote his sister postcards and told her about the world outside of Hawthorne.

It is an eerie coincidence that William Johnson should send this postcard. The card was dated July 1908 (still four years away from the *Titanic*'s sinking in April 1912, and seven years from the *Lusitania*'s sinking in the spring of 1915). He wrote, "The *New Hampshire* is just like this boat only different. I saw the *Roosevelt* the boat that Perry is going to the North Pole in [Adm. Robert Peary was considered the first man to step foot on the North Pole in 1909]. There is also here at New Bedford a whaling vessel from the South Seas. We got here at 6 o'clock and I got off at 5:10 o'clock. Give my love to all. From your loving brother, Willi."

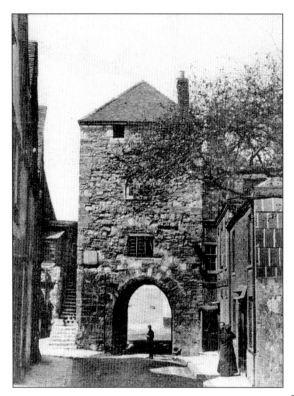

William Johnson wrote this postcard to his sister, Bessie, and it is dated September 11, "8:00 The new job is great. Had to climb up the mast 3 times coming over be course the lights went out. How is Hawthorne. This place [Southampton, England—a popular port he had been to several times] is bum is worse every time I come. With love, Will."

Tom Malcolm is pictured here with two rabbits outside the Janes homestead. Ebenezer Janes built the first house on Diamond Bridge Avenue in 1867. He was concerned about building a post office, which was later built on Diamond Bridge Avenue (refer to chapter 5).

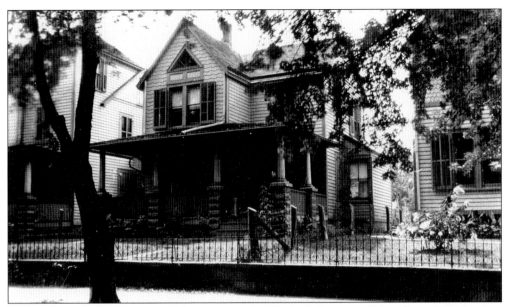

Although it was built over a 120 years ago, the Florence house still stands on Rea Avenue. Patricia Florence said this was where she lived her whole life. She recalled that when her family moved in, in the 1920s, there were still gas lamps, a pump for water, and an outhouse in the backyard. She added that everything had been updated by the 1940s.

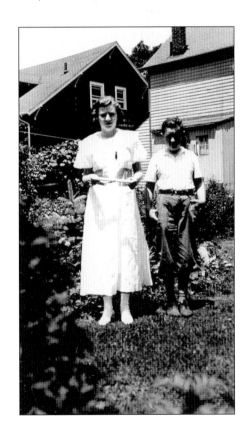

Patricia Florence poses for a graduation photograph with her brother Harold Florence, who is two years younger than she. After World War II, she spent time teaching in Japan.

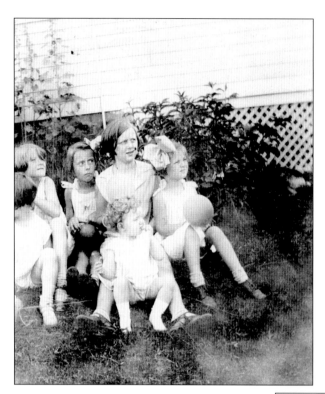

Patricia Florence sits with her friends in this 1931 photograph, taken at the house on Rea Avenue. She was nine years old and had just been playing ball with her "female chums" when this photograph of her holding the toddler in the front was taken. What was to their left that caught their attention is lost to history.

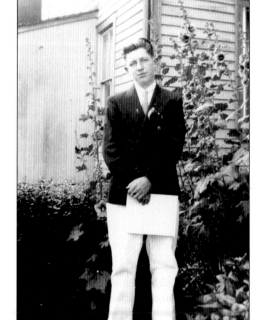

On his middle-school graduation day, Harold Florence stands with his diploma in hand on the side of the house near the flower bed at his Rea Avenue home. Patricia Florence said her younger brother was a joy and a pleasure to know.

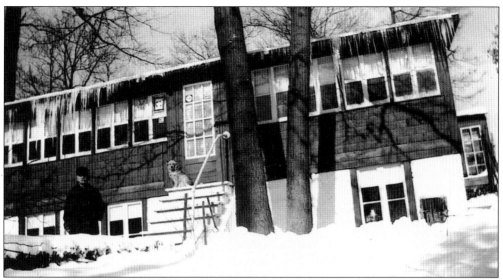

Members of the Van Buskirk family facetiously refer to the house in this 1944 photograph as their summer home. Van Buskirk was a family name in Hawthorne in the early 1900s. Cold or not, Melvin Van Buskirk and his dog survived the temperature.

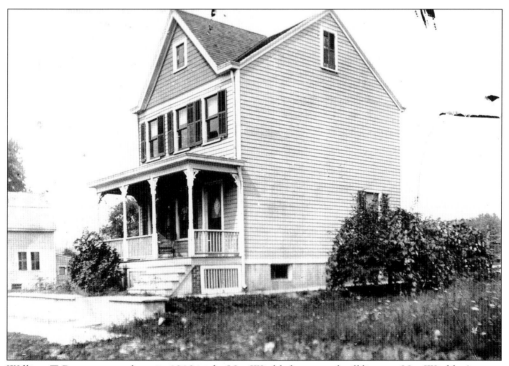

William T. Patterson was born in 1910 in the Van Winkle house and still lives on Van Winkle Avenue today. Between the two Van Winkles in his life, he lived at this house, on Lafayette Avenue.

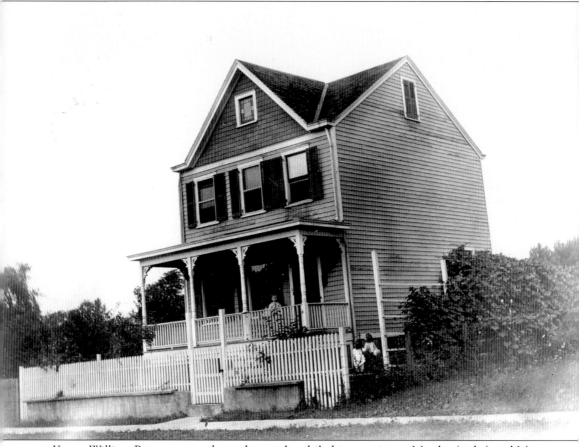

Young William Patterson stands on the porch, while his two sisters, Martha (right) and Mary, stand off to the side. Note the shrub on the side of the house is larger than it appears in the previous photograph.

William Patterson's mother, Mathilda Patterson, sits with one of her three children. She came to the United States from Ireland to marry Marcus Patterson in 1909. When she arrived, they immediately got married in a civil ceremony because she refused to move in with someone she was not married to.

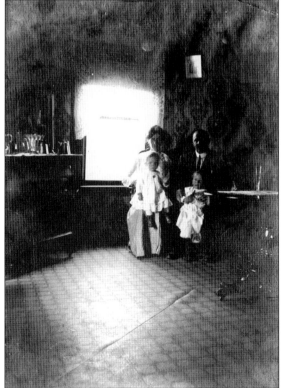

William and Martha Patterson sit with their parents inside of their Lafayette Avenue home. Marcus Patterson was invited by his cousins George, Thomas, and William Arnold to be the night manager of their plant, a silk-dyeing mill in Hawthorne. He lived in the Van Winkle home as a tenant for two years before he married and had his first two children there.

William Patterson told the story that when he was born, the doctor was brought to the Van Winkle homestead. However, because the doctor had a bad back, William's mother gave birth to him on the dining room table, so the doctor was able to sit comfortably.

At about age five or six, William Patterson pedals his tricycle at his Lafayette Avenue home in front of a fence lined with chicken wire. This photograph was taken by his father, Marcus Patterson, who took pictures and developed them himself.

William Patterson sits with his sister Martha and their dog Leo on the front steps of their Lafayette Avenue home. He has his bee-bee gun ready to fire at a moment's notice. The photograph was taken during the World War I years.

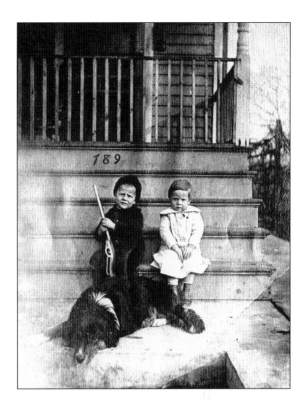

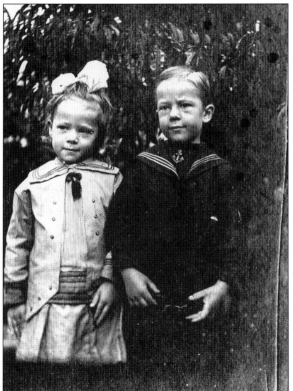

William and Martha Patterson set sail. The two of them are ready for an outing—note the way his hair is combed and the bow on her blouse. Martha was born in 1912 at the Van Winkle home, like her brother who seems to have a penchant for sailor suits.

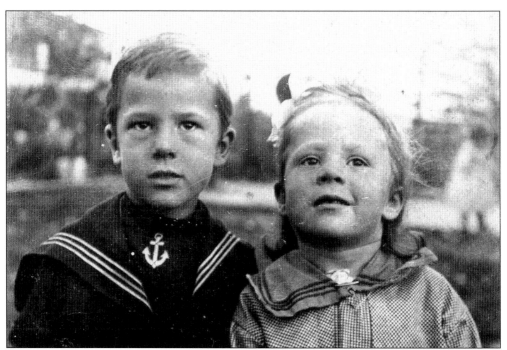

In this close-up taken by Marcus Patterson, son William has tousled hair and daughter Martha has no bow on her blouse. The child over Martha's left shoulder is probably her sister, Mary.

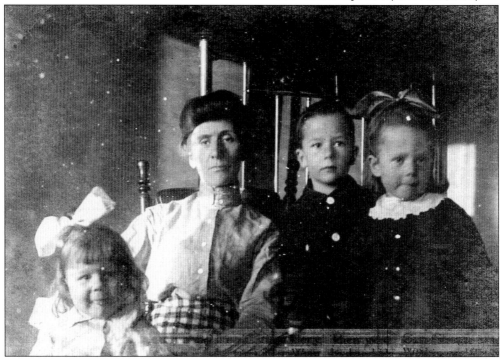

Mary Patterson has a mischievous smile on her face as she sticks out her tongue. With her are sister Martha, their mother, and brother William Patterson. The indoor photograph was taken on a sunny day.

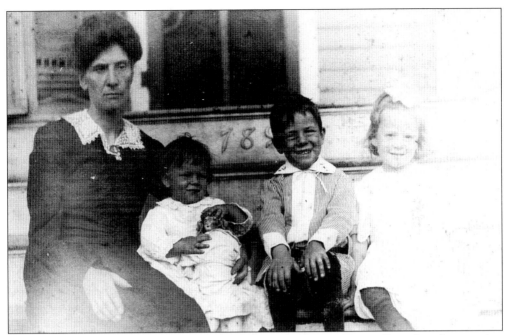

While Mary (second from left), William, and Martha Patterson are all smiles, their mother maintains her serious expression. Their mother was a high school English teacher and, according to William, felt she needed to remain upright and above reproach at all times.

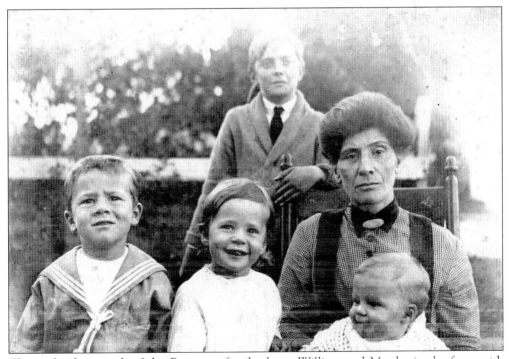

This early photograph of the Patterson family shows William and Martha in the front with Mary, at this time an infant, their mother, and their friend William Little, the son of a local Presbyterian minister, in the back wearing the tie.

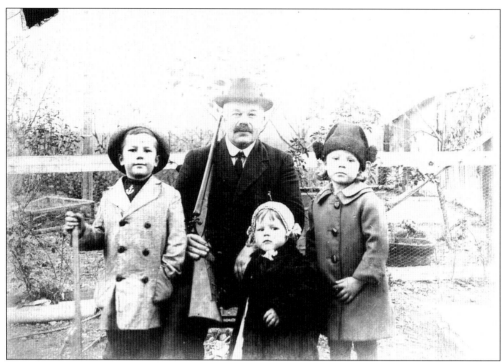

William Patterson recounts that when he was seven, his father, Marcus Patterson, said to him, "You are going to help me clean out the chicken coop of rats." As his father banged on the boards of the coop, scaring the rats out of their hiding place, William hit them with a baseball bat. "I killed 42 rats that day," he recalled, "and today I have no fear of rats whatsoever." Here, he poses with his father and sisters, Mary and Martha (right).

Martha (left), William, and Mary Patterson pose outside their home.

Mary Patterson (left) holds her doll, William Patterson holds his knees, and Martha Patterson sits back and relaxes. After being in so many photographs, Martha was becoming a pro.

Martha Patterson, many years later, sits in her own living room with her own dog on her lap. She passed away in the 1990s. Her sister, Mary, passed away in the early 1980s.

Mary Patterson, Mary Van Dyke here, poses this time holding a real baby—her son. She has the same smile as she did in a previous photograph.

William Patterson is pictured here in 1956. His father, Marcus Patterson, died when William was 16. The boy chose a burial spot for his father and stayed around to help his mother and his sisters. The 1929 Central High School yearbook describes him as "dependable, conscientious, and possessing a good deal of common sense." He worked selling beauty products and school supplies to local stores and, later, took over ownership of the store. When he retired at age 80, he became involved with Gideons International. Today, at 95, he continues to share a good life with his wife, Joan, and their children and grandchildren.

Earlier, William Patterson took the opportunity to travel to New Zealand, which he claims was one of the best experience in his life. On the back of this photograph, it says, "Bill with sheep friends in New Zealand looking for a good toupee!"

While in New Zealand, William Patterson visited an area with geysers that spew water into the air.

This photograph of 789 Lafayette Avenue was taken in 1989. Today, it is a two-family house.

In 1947, Ruth Ursula Markus moved with her family from Paterson to this house in Hawthorne, on Horton Avenue. According to her daughter Alyssa Barkenbush, it is said that this house was once either a dollhouse factory or a crate factory.

This photograph of the Markus house was taken from a different angle. When Ruth Markus lived on West Broadway in Paterson, she attended the Public School No. 5, from which she received a certificate for her attendance record.

Ruth Markus smiles at the icicles hanging from the edges of her home in 1947. The photographer's experiment gives the picture a wintry look.

Another photograph with the same wintry effect shows how the neighborhood had grown up around the Markus home by December 1947.

Ruth Markus stands outside her home. The house was built when the railroad came to town in the early 1900s. Notice the open garage door. This style of door was common at the time. The folding overhead garage door was not invented until 1926.

During the first half of the 20th century, local newspapers often carried brief mentions of simple social events such as parties. One such example stated: "A Hallowe'en party was held at the home of Mr. and Mrs. Markus on Friday evening. . . . The evening was spent in a program of seasonal games and late hour refreshments." In attendance were 20 guests.

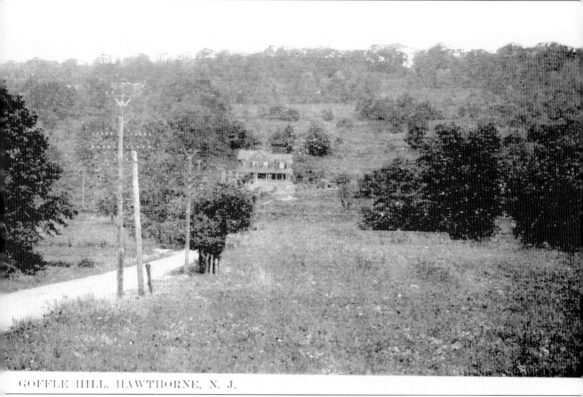

This early 20th-century view shows Goffle Hill, across from Goffle Brook Park. According to old reports, children would play in the hills, "with the singular house sitting on the side of the mountain." In fact, it was reported that hikers would trek up to this part of Manchester to hike "the Hawthorne Hills" and some would stop by the Van Winkle home and look at the crypt of the murdered judge and his wife.

Three

GOFFLE

Goffle Brook Park is the centerpiece of the town of Hawthorne. Whenever there is an event or place for schools to practice, the park is immediately the first choice.

It boasts several ball fields, soccer fields, and parks with swings and slides where parents can take their children.

In 2004, the park was used by the fire department, police department, and the emergency paramedic team as the site of a rescue training exercise. A firefighter played the part of a hiker with a broken leg, and the rescue crews practiced their skills.

Goffle Brook Park is the scene of "Morning in Hawthorne," a poem by Janet W. Dunnett.

> We climbed the Watchung's highest peak
> To view the landscape o'er
> And in the valley at our feet
> Lay the town that we adore.
>
> The sun came glimmering through the mist
> The lovely autumn morning
> Each blade of grass with dew was kissed
> The mountainside adorning.
>
> The myrtle bloomed and wandered there
> Where Nature firmly sets it
> God's handiwork is ever fair
> But man; so soon forgets it.

Tom Malcolm was "a kindhearted person who knew everything about Hawthorne," according to Betty Ann DeKnight. He could be Tom Sawyer's double, as seen in this 1920s photograph.

When the winter days were over, the call of Goffle Brook and Patsy's Pond was hard to resist. Tom Malcolm (left) and friend Eddie Gill spend one of many long summer days together in Hawthorne in the 1920s. The two boys hid in the cornfields and galloped through the Goffle woods.

Eddie Gill casts his rod in Patsy's Pond. The pond was a popular place to play in the 1920s and the 1930s. The children would fish and act out a Mark Twain story or two.

In his Sunday school best, Tom Malcolm shows what he and Eddie Gill caught in Patsy's Pond. Things changed after the County Board of Passaic turned Goffle Brook Park into a national park.

As a boy gets older, fishing, hide-and-seek, and other games take a back seat to maturity. So, here is Tom Malcolm a few years later ice-skating on Patsy's Pond with Ruth Cocker Rube (left) and Grace Cocker Stephens.

At one time Patsy's Pond not only had fish but also ice-skaters, like Tom Malcolm. Ice-skating was a common winter sport. When Sunday dinner was cleared away and nothing else was going on, it was nice to go to Patsy's Pond, put on a pair of skates, and before one knew it, the afternoon was gone.

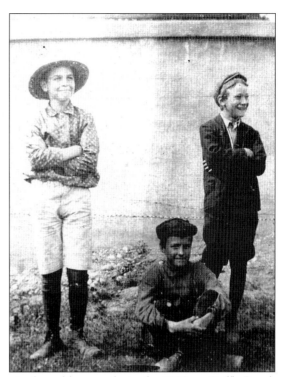

Tom Malcolm (left) enjoys another moment in the colder months in the 1920s at Goffle Brook Creek somewhere north of Diamond Bridge Avenue. William Johnson (right), the *Titanic* victim, spends a day at Goffle Brook Park with his friends Herbert Russell (left) and a boy identified only as Ferdy.

Goffle Brook Park is pictured in 1900. This is what the park looked like near Warburton Avenue—close to where the high school was built. Taken by Fred Mensel, the photograph was in the possession of Florence Heyns, given to Ethel Anderson in 1973, and later found in the collection of the Van Buskirks.

Goffle Brook is sometimes the place to hold special concerts and celebrations. In the middle of the day in the 1950s, three children listen to four men perform for the citizens of town. The quartet is accompanied by a local orchestra.

Rea Avenue resident Patricia Florence smiles in the chilly sunlight at Goffle Brook Park. The houses behind her are those that line the side of Goffle Road.

Four

SACRED PLACES

From Colonial times up to pre–Civil War days, local inhabitants had no church of their own to attend. For Sunday services, they had to take a lengthy ride by horse and wagon to Paterson, Paramus, or other places, according to the *Tercentenary Souvenir Book*.

After the Civil War, the local population grew, and "the need for some religious teaching became apparent."

The book notes that "There are known records of the origin of the Hawthorne Sunday School, although some of the early members spoke of a man who sat on the steps of [a local business] and told Bible stories and sang hymns to the children who gathered around."

Czech-born poet, playwright, and novelist Franz Werfel, who fled to America from the Nazis, said it best: "Religion is the everlasting dialogue between humanity and God."

Hermann Braunlin (1904–1995) was a driving force for what is today Hawthorne's largest church, Hawthorne Gospel Church. Braunlin (left), who grew up in Paterson and helped lead the Bible study group, had taken part in revival services held by baseball-player-turned-evangelist Billy Sunday. Braunlin served as pastor emeritus in 1986, when John W. Minnema was installed as senior pastor. The church's first edifice (right) was built at 634 Lafayette Avenue in the 1930s. Later, a new church was constructed on a 22-acre lot off Route 208.

The Van Buskirk family stands in front of the Rea Avenue Reformed Church in the 1940s. The church is located off Lafayette Avenue.

The Sunday school class of the Rea Avenue Reformed Church is pictured in 1910. At one time the church was called the North Paterson Reformed Church. Edna Hascup, now of Margate, Florida, says that her grandparents were involved in the construction of the church.

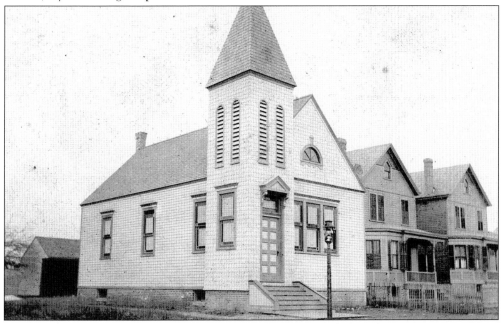

This was the church in which the local Reformed groups met before the current Rea Avenue Reformed Church was built. The church has its roots from the years just after the Civil War. According to researcher Tracy Galloway Gaehring, "In 1866, the year after the close of the Civil War, several families in the area of Goffle Hill and Goffle Roads organized a mission Sunday School. This work was carried on first in the various homes of the sponsors in the vicinity and then in the school, which stood at the foot of Goffle Hill. This project was so promising that effort was made to erect a chapel on Goffle Road opposite the Rea homestead. This effort was unsuccessful; instead the group was divided and a part withdrew to organize the Union Hawthorne Sunday School, which subsequently erected the building on the corner of Goffle Road and North Eighth Streets. The other group continued to hold services in the schoolhouse on Goffle Road."

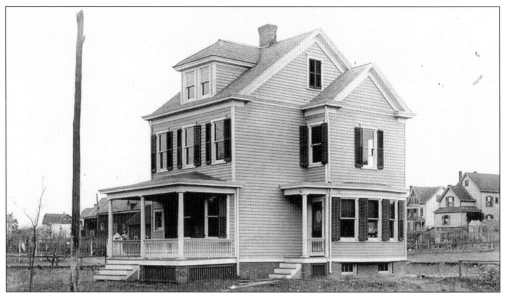

The original pastors of the church resided in this parsonage, near the Rea Avenue Reformed Church. Pastors from 1895 to 1969 were Garret M. Conover (June 1895–December 1897), William Johnston (May 1898–November 1900), James Martin (May 1902–June 1905), Isaac J. Van Hee (September 1905–December 1906), Charles Herge (January 1907–November 1912), H. W. Maas (June 1913–March 1914), A. A. DuBois (April 1914–July 1915), Elias B. Van Arsdale (July 1916–July 1936), Bastian Kruithof (January 1937–November 1942), D. Ivan Dykstra (April 1943–January 1947), Gerald A. Heersma (September 1947–May 1960), Marvin D. Hoff (June 1961–January 1966), and Frank J. Shearer (October 1966–September 1969). These names and dates were compiled by Tracy Galloway Gaehring.

The Rea Avenue Reformed Church was organized on December 18, 1894. Its 15 charter members were Elmer Ellsworth and Florence Lent Carlough, Henry and Minnie Tanis Braen, Jennie Van Allen, Agnes Ackerman, Martin Braen, Mr. and Mrs. John A. Vrooman, William H. and Anna Dancy Roat, Garrett H. and Annie M. E. Van Dein, and Warren H. and Mary L. Coburn. Further, according to Tracy Galloway Gaehring, Vrooman, a train conductor, was the first "received on confession of his faith in Christ."

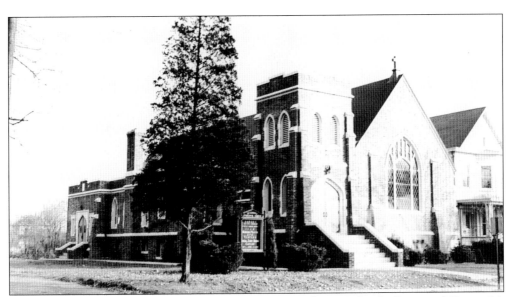

Saint Clements Episcopal Church was founded in the early 1900s by the Reverend George M. Dorwart, who was then the pastor of the Church of the Holy Communion in Paterson. Dorwart founded the Saint Clements Episcopal Mission, which had its origins in Paterson before moving to Hawthorne. The mission held services in the municipal building before Saint Clements Episcopal Church, pictured here in 1936, was built sometime later.

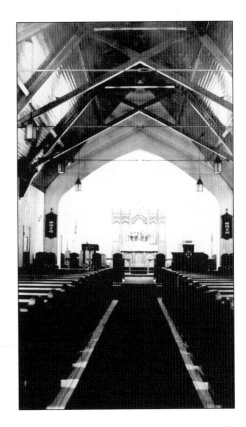

Former mayor Louis Bay II was one of many members of Saint Clements. This interior shot of the church shows the Gothic style, common among houses of worship, which was meant to inspire the parishioners with a feeling of awe.

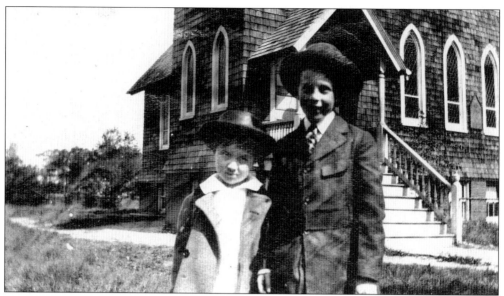

Tom Malcolm (right) and his friend Robert James pose for a photograph in front of their church, Saint Clements.

Betty Ann DeKnight's grandmother Bella (second row, second from the left) sits with the Saint Clement's Sunday school class in 1900. The class may have been meeting outdoors (in nicer weather) because, at this time, Saint Clement's Church had not been built.

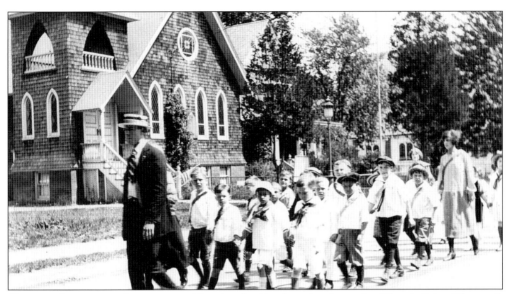

On special occasions, the town would gather for Sunday school parades. Here is Saint Clement's boys' Sunday school class marching along. This photograph and all of the subsequent Sunday school parade pictures are from Thomas Malcolm's collection.

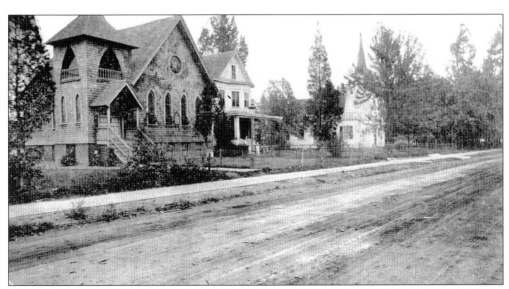

Saint Clements is on the left, and Hawthorne Reformed Church is on the right. Also located on Lafayette Avenue, the Reformed Church is one of the oldest churches in town.

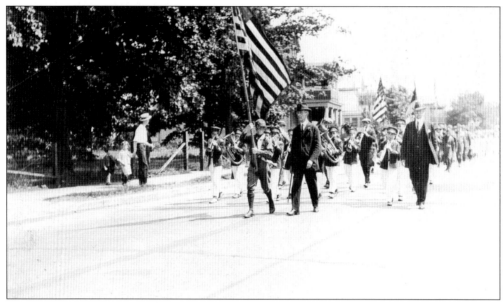

Sunday school students march as part of a Sunday school parade. A member of the Boy Scouts holds an American flag. In those days, churches in the area would sponsor Scout troops.

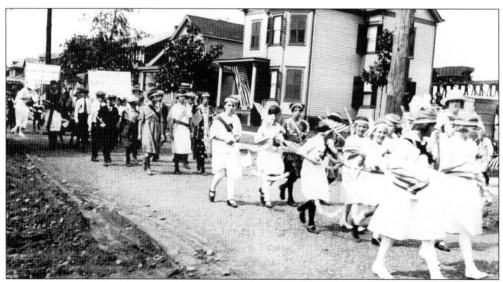

A girls' Sunday school classes marches on Lafayette Avenue. However, the railroad bridge in the back is no longer there.

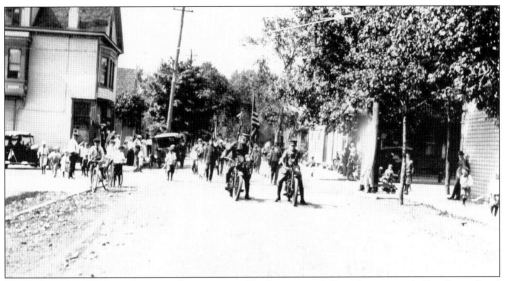

This photograph was taken on the corner of Lafayette and Rea Avenues. A Sunday school parade is being led by two policemen on motorcycles. On the left is a grocery store that once belonged to Hawthorne resident Mary Brogan.

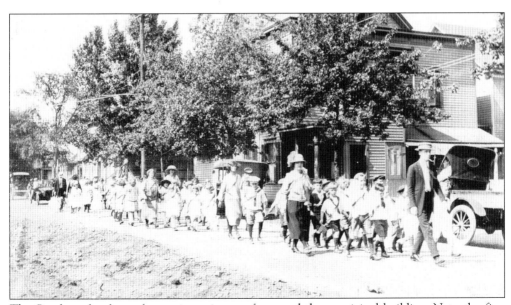

The Sunday school parade continues its march toward the municipal building. Note the fine clothes and the cars of the time.

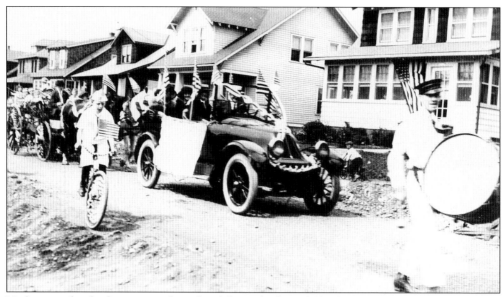

Unfortunately, the banner on the side of this vehicle is difficult to read. The cart behind the automobile is being pulled by two horses. Longtime residents recall that horse farms once existed along Van Winkle Avenue between Lincoln Avenue and what is now Route 208.

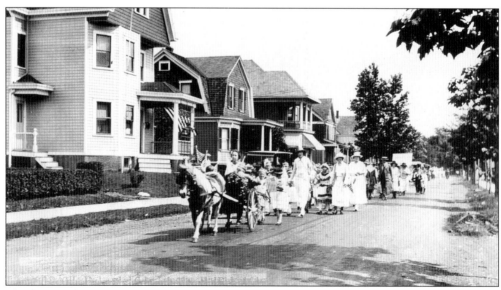

The beast of burden in the front of the cart pulls some churchgoers and takes the lead among this group of women and children as they march down Lafayette Avenue.

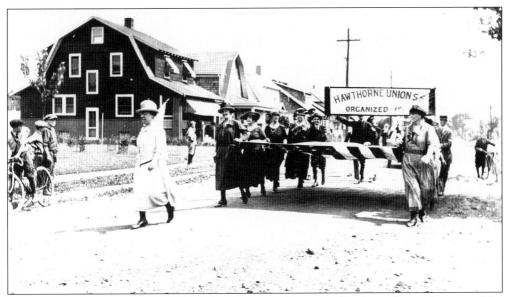

Members of Hawthorne's women's auxiliary carry an American flag down the road as part of the Sunday school parade. Two boys on bicycles (left) stop to watch this band of marching women carry on as they carry the flag.

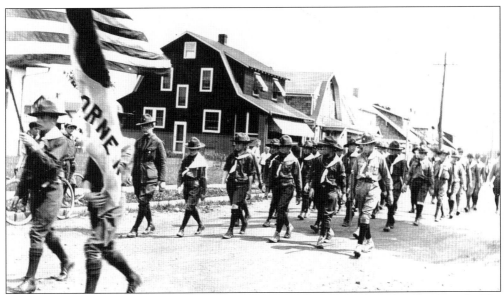

The Boy Scouts sponsored by the Methodist Church march as part of the Sunday school parade. The Scout carrying the American flag is identified as Sikko Engels ("Sikko" is probably a nickname).

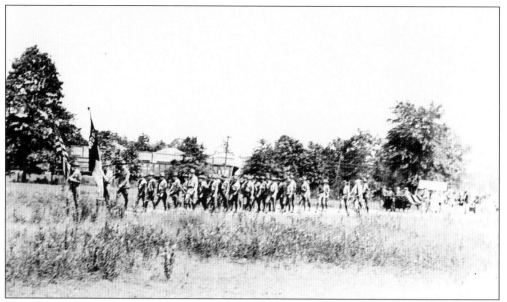

Here the troop marches behind the former municipal building. At the time, it was Lafayette School, but the Scouts here lead this group of people. Note the cart with the American flag draped on it (right).

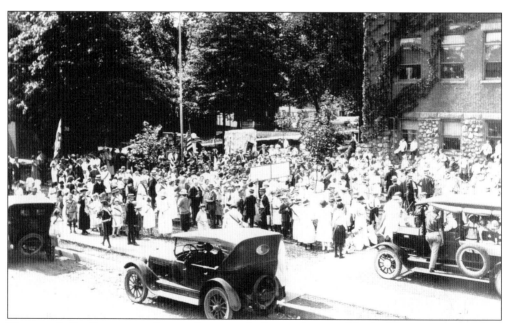

The parade finally comes to its conclusion on Lafayette Avenue. The building was at one time a school but later changed to the town hall. In later years, it burned to the ground, and it was then replaced with a more modern structure.

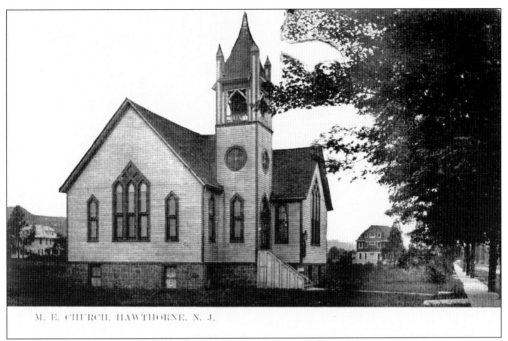

M. E. CHURCH, HAWTHORNE, N. J.

In 1916, the Hawthorne Methodist Episcopal Church was located on the corner of Lafayette and Warburton Avenues. The church was originally organized in the home of B. J. Jones in April 1895. Sylvester Utter sat on the first board of trustees.

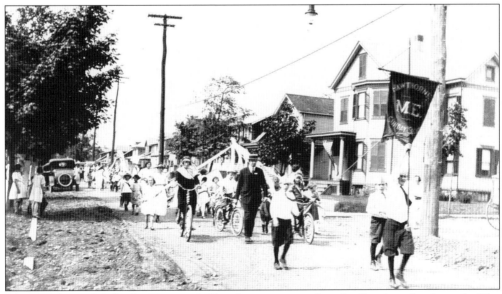

The Hawthorne Methodist Episcopal Church is represented in this Sunday school parade. The letters "M" and "E" can be made seen on the banner in the front, which is being held by one of the young parishioners.

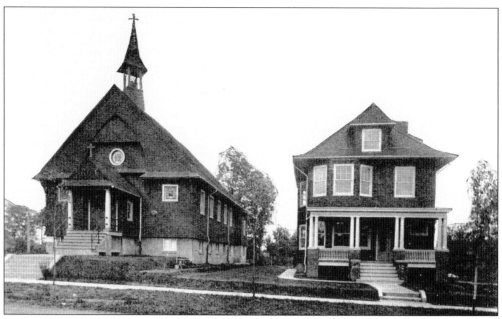

The Reverend Anthony Stein of Our Lady of Lourdes Church in Paterson founded Saint Anthony's Roman Catholic Church in Hawthorne in 1908. Saint Anthony's was founded at the request of the 20 families who lived in Hawthorne and did not have a place to worship, since the churches in the nearby area were Protestant.

The area to the left of the Jewish Cemetery was once sold to the local Dutch churches to bury their dead. Most of the dead were exhumed and later taken to a cemetery in Fair Lawn. However, another part of the land was sold to David Worthing and Joseph Brown of the Congregation Ahavath Joseph in Paterson. The tombstones in the cemetery are written in English, Hebrew, or Yiddish. Several of them are not the oval gray shapes. Instead, some have been carved in the shapes of trees, representing the Torah, the first five books of Moses. This cemetery contains about 100 people who were part of the Paterson congregation. The earliest dates on the tombstones go back to 1803, and the most recent ones go up to 1992. Many of the stones are dated 1918. Between 1918 and 1919 a flu epidemic, often called the Spanish Flu, broke out. The flu actually decreased the life span of Americans by at least 10 years, thus killing an estimated 700,000 Americans.

Five

Municipal Services

When Hawthorne became a borough in 1898, it was already plagued with a variety of municipal problems. According to a book celebrating Hawthorne's 50th anniversary, "few of the existing streets were paved; police protection was demanded; new streets were requested; telephone service, electric service, transportation facilities and sidewalks were desired. Each day brought more pressing demands from the borough citizens." Soon, the process of attending to these problems was under way. "By the end of the first year every phase of municipal problems had been faced and considered."

Between 1898 and 1911, the mayor was elected by the people. Thanks to Walsh Act of New Jersey, the town adopted a commission form of government and elected three commissioners. One of those three were chosen to be the mayor. In 1911, the first commissioners were Reuben MacFarlance, Sylvester Utter, and Arthur Rhodes.

Hawthorne was governed this way until the late 20th century, when the town voted to elect a mayor rather than continue with the three commissioner system.

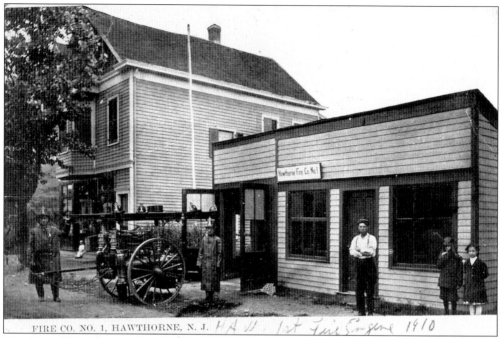

FIRE CO. NO. 1, HAWTHORNE, N. J. *HA H. 1st Fire Engine 1910*

Members of Hawthorne Fire Company No. 1 pose with a hand crank pump in the early 1900s. The two children on the right wanted to be included in the picture.

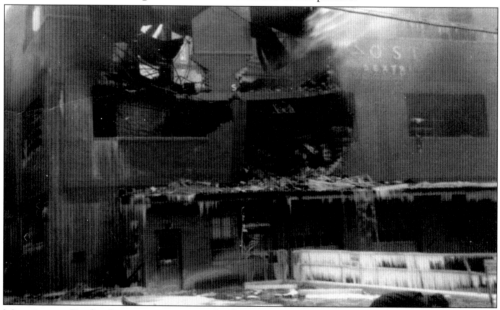

Morningstar-Paisley Inc. traces its routes back to the 1850s. With companies all over the world, it once specialized in manufacturing the adhesive used for the packing industry. It worked with starches, dextrines, processed gums, adhesives, and specialty chemicals. In 1967, however, an explosion occurred at the plant and 11 people were killed and 8 were taken to the hospital. The Morningstar-Paisley managers were cleared of responsibility for the explosion and fire by the New Jersey Department of Labor and Industry, and immediately afterward, the company began to discuss rebuilding.

This devastation was left behind as flames gutted the brick building of Morningstar-Paisley. All anyone could do, like the man on the right, is watch the flames burn. Even today, people still talk about the fire and the destruction.

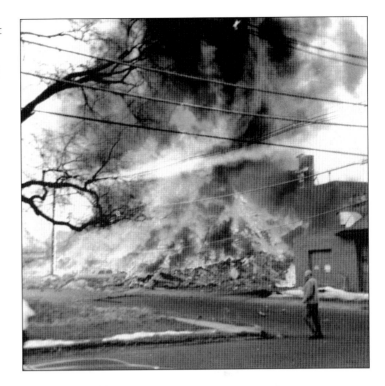

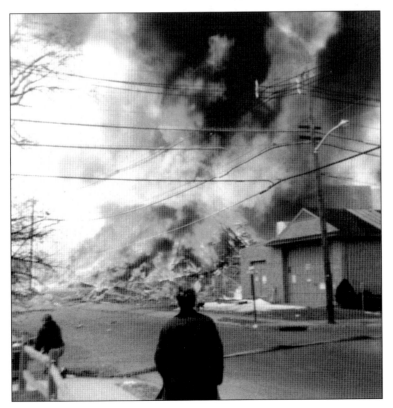

This view, of the same side of the Morningstar-Paisley building as is seen above, shows how high the flames reached. The woman in the photograph can only stand and watch as the fire burned on. Hawthorne firefighters were able to prevent the flames from spreading to other buildings.

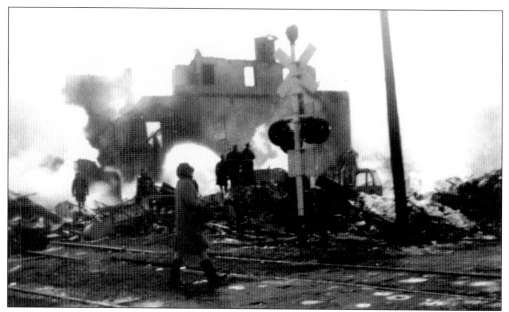

A person walks across the railroad tracks as the smoking remains of the Morningstar-Paisley building show the fire is slowly coming to an end. Many of the residents who were around at the time still recall the fire and say it was one of the worst in the borough's history.

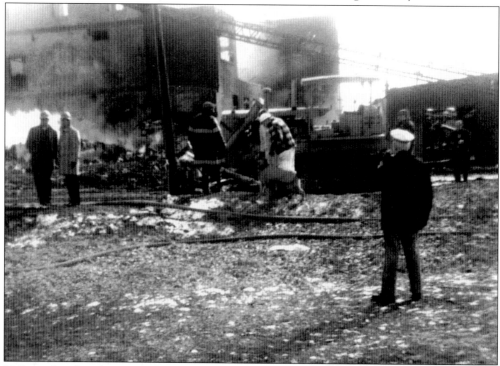

Helmeted workers begin to sift through the wreckage of the Morningstar-Paisley fire. In front of the bulldozer, a German shepherd named Silver walks with his master, 51-year-old Bill Short, who was visiting Manhattan from Quebec, Canada. Short brought Silver to Hawthorne to help locate anyone trapped during the explosion. The dog later found the bodies of three men.

A fire official heads toward the side of the Morningstar-Paisley building that has not been damaged by the fire. Many of the neighbors were in no hurry for the company to rebuild and start work again.

A Paterson newspaper reported that nearby cars, trucks, and vehicles "were destroyed by flying bricks and other debris" from the Morningstar-Paisley explosion. Witnesses reported that the air was filled with flying objects and the heat from the flames that engulfed the building was searing.

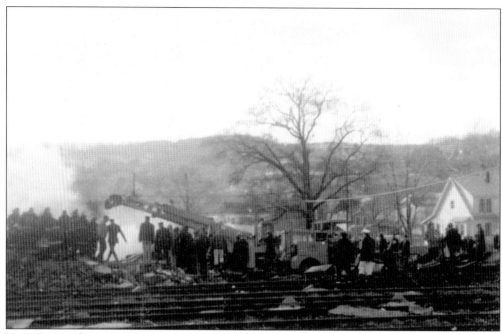

Irene DeGraaff wrote a firsthand account of the fire: "I was working in my kitchen preparing dinner for my girls . . . when all of a sudden my house started to shake. I thought my iron railings were going to shake off the house. I was stunned for a minute. I thought my furnace blew up."

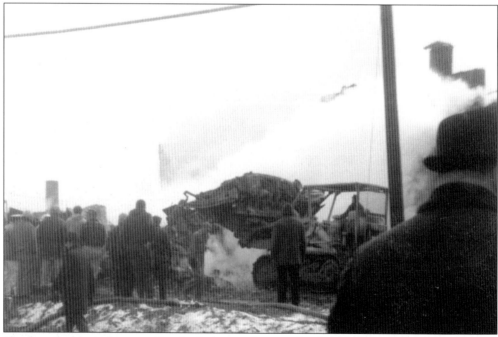

She described how she ran to her back door and saw a cloud of black smoke and things flying in the air. "I knew then that something exploded . . . when I rounded the corner of Florence Avenue. . . . I was shocked by what I saw. The Morning Star Paisley plant was already down to the ground and burning furiously."

Irene DeGraaff described how her daughter arrived home crying because one of her playmates had almost been killed. "[The boy] was walking another boy home from school at the time and saw the building explode." She summed up the experience by saying, "Yes, it was a tragedy. Yes, Hawthorne will never forget the day of the great explosion."

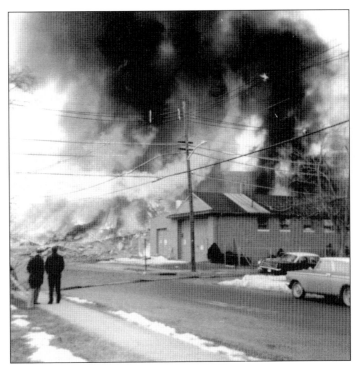

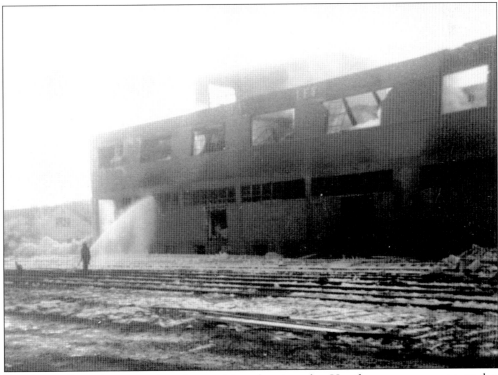

Residents of nearby areas signed a petition, begging the Hawthorne government to bar Morningstar-Paisley from rebuilding because of its use of chemicals. People were concerned that use of the same chemicals could cause another explosion. The factory was never rebuilt.

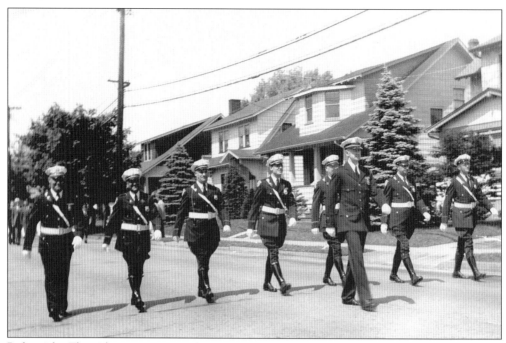

Before "the Thin Blue Line" was established in 1928, the borough kept the peace with part-time marshals. The first headquarters was established in an old school building across from the waterworks on Goffle Road. The men worked in 12-hour shifts, providing 24-hour protection.

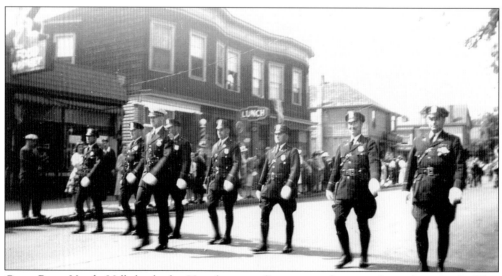

Capt. Ryan VanderValk leads the Hawthorne policemen as they march in this parade. This photograph came from the personal collection of John Holmes, a Hawthorne patrolman.

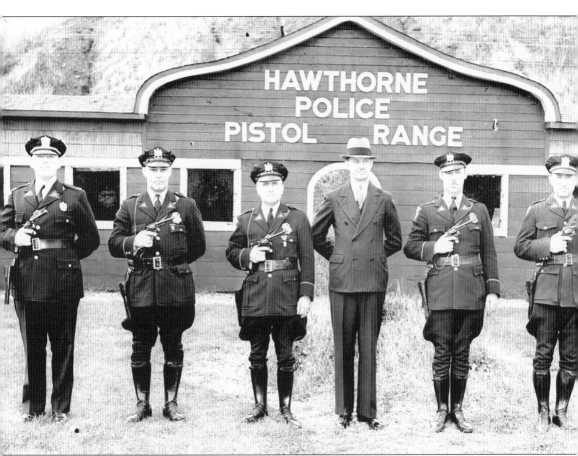

This 1939 picture, taken at the pistol range, shows Hawthorne's finest standing ready. From left to right are Capt. Leslie Henion, patrolman Charles Kenyon (later chief), patrolman John Holmes, Chief Ryan VanderValk, patrolman Robert Rollo, and patrolman Joseph Putz (later captain). Henion and Holmes were two original 1928 officers. Putz and Rollo came on in 1929. Kenyon was added to the department in 1931. The pistol range was destroyed in a fire not too long after this photograph was taken.

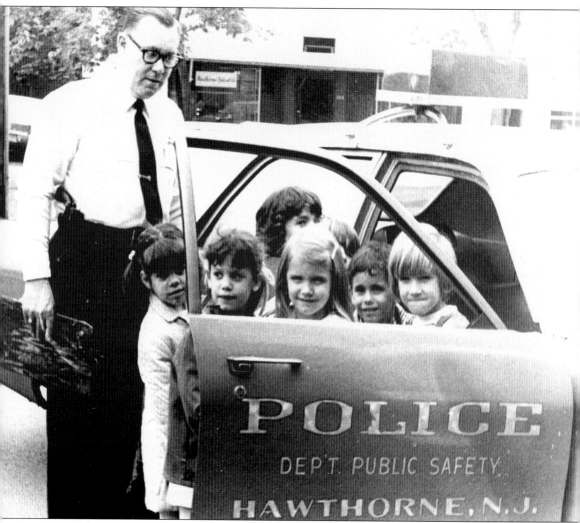

As part of the Hawthorne Police Department outreach program in the early 1970s, former police chief Charles Kenyon shows some schoolchildren what is on the inside of a police vehicle. One can almost hear the children begging, "Turn on the siren! Turn on the siren! Can you flash the lights?"

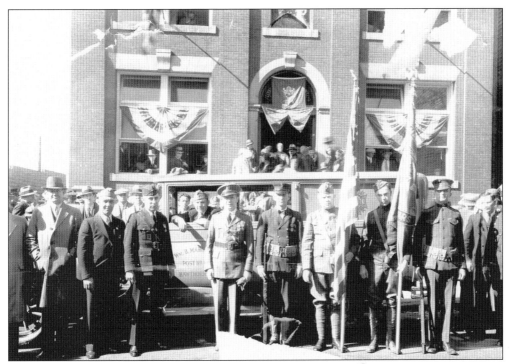

This ambulance owned by the William B. Mawhinney Post 1593, Veterans of Foreign Wars was one of the earlier vehicles used in a long line of rescue units. The rescue vehicles are part of the William B. Mawhinney Volunteer Ambulance Corps.

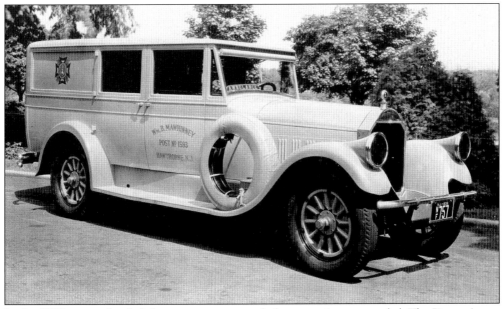

In the 1930s it was decided that an emergency ambulance service was needed. The Pierce-Arrow was originally owned by the Parish family of Wayne Township. Vandenberg and Sons bought and rebuilt it. On May 30, 1932, a ceremony was held to unveil the ambulance.

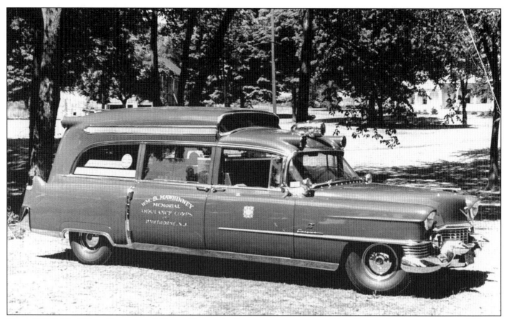

The 1954 Cadillac Sayer and Scoville ambulance was acquired by the ambulance corps. "Upon [its] arrival in town, this ambulance created quite a stir, since it was a bright red," according to a history of the ambulance corps. "We sincerely hope that you never need our services, but rest assured that should it become necessary, we will be there."

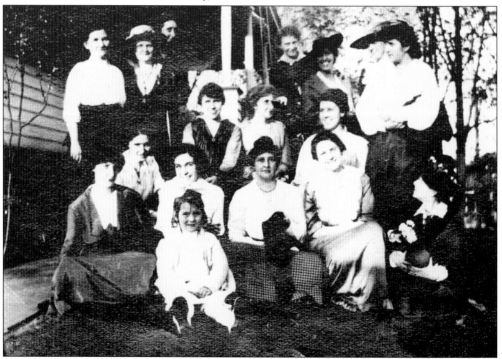

The library organization originally met in the home of the Adolph Sieker family in 1913. This photograph was taken in 1916. At one time the library was in the Post Office Block and housed 1,300 books, plus 44 weekly and monthly newspapers and magazines.

Hawthorne's librarian checks out books and organizes them in appropriate section. The town's original librarian, Harriet d'Archambaud, served from 1913 until her death in 1945.

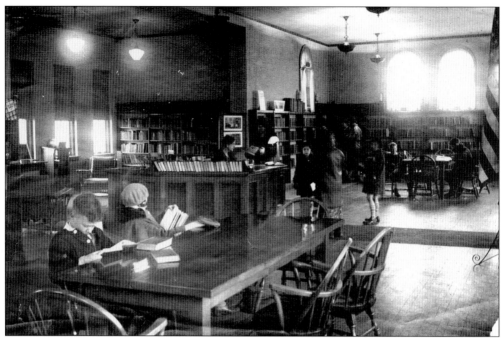

The library was originally located at the Lafayette School. Later, it was relocated to a store on Diamond Bridge Avenue. Ultimately, it was moved to its current location on Lafayette Avenue.

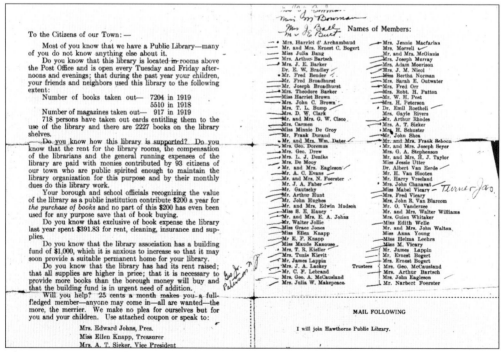

To the Citizens of our Town: —

Most of you know that we have a Public Library—many of you do not know anything else about it.

Do you know that this library is located in rooms above the Post Office and is open every Tuesday and Friday afternoons and evenings; that during the past year your children, your friends and neighbors used this library to the following extent:

Number of books taken out— 7204 in 1919
5510 in 1918
Number of magazines taken out— 917 in 1919

718 persons have taken out cards entitling them to the use of the library and there are 2227 books on the library shelves.

Do you know how this library is supported? Do you know that the rent for the library rooms, the compensation of the librarians and the general running expenses of the library are paid with monies contributed by 93 citizens of our town who are public spirited enough to maintain the library organization for this purpose and by their monthly dues do this library work.

Your borough and school officials recognizing the value of the library as a public institution contribute $200 a year for *the purchase of books* and no part of this $200 has even been used for any purpose save that of book buying.

Do you know that exclusive of book expense the library last year spent $391.83 for rent, cleaning, insurance and supplies.

Do you know that the library association has a building fund of $1,000, which it is anxious to increase so that it may soon provide a suitable permanent home for your library.

Do you know that the library has had its rent raised; that all supplies are higher in price; that it is necessary to provide more books than the borough money will buy and that the building fund is in urgent need of addition.

Will you help? 25 cents a month makes you a full-fledged member—anyone may come in—all are wanted—the more, the merrier. We make no plea for ourselves but for you and your children. Use attached coupon or speak to:

Mrs. Edward Johns, Pres.
Miss Ellen Knapp, Treasurer
Mrs. A. T. Sieker, Vice President

Names of Members:

Mrs. Harriet d' Archambaud
Mr. and Mrs. Ernest C. Bogert
Miss Julia Bang
Mrs. Arthur Bartsch
Dr. E. W. Bradley
Mr. Fred Bender
Mr. Fred Broadhurst
Mr. Joseph Broadhurst
Mrs. Theodore Barker
Miss Harriet Brown
Mrs. John C. Brown
Mrs. T. L. Bump
Mrs. D. W. Clark
Mr. and Mrs. G. W. Cisco
Mrs. Carmen
Miss Minnie De Groy
Mr. Frank Durand
Mr. and Mrs. Wm. Dater
Mrs. Geo. Doremus
Mrs. Geo. Drew
Mrs. L. J. Denike
Mrs. De Mooy
Mr. and Mrs. Eagleson
Mr. A. C. Evans
Mr. and Mrs. N. Foerster
Mr. J. A. Faber
Mr. Gautschy
Mr. Arthur Hunt
Mr. John Hughes
Mr. and Mrs. Edwin Hudson
Miss S. E. Haney
Mr. and Mrs. E. A. Johns
Mr. Walter Jollie
Miss Grace Jones
Miss Ellen Knapp
Mr. E. F. Knapp
Miss Maude Kanouse
Mrs. T. R. Kieller
Mr. Tunis Kievit
Mr. James Lappin
Mrs. J. A. Lackey Trustees
Mr. C. F. Lebrand
Mrs. Geo. A. McCausland
Mrs. Julia W. Makepeace

Mrs. Jennie Macfarlan
Mrs. Morrell
Mr. and Mrs. McGinnis
Mrs. Joseph Murray
Mrs. Adam Moorison
Mrs. J. M. Nicol
Mrs. Bertha Norman
Mrs. Sarah E. Outwater
Mrs. Fred Orr
Mr. Robt. H. Patton
Mr. W. H. Post
Mrs. H. Peterson
Dr. Emil Roetheli
Mrs. Gayle Rivers
Mr. Arthur Rhodes
Mrs. A. T. Sieker
Mrs. H. Schuster
Mr. John Shea
Mr. and Mrs. Frank Schoon
Mr. and Mrs. Joseph Seyer
Mrs. G. A. Stephenson
Mr. and Mrs. H. J. Taylor
Miss Jessie Utter
Dr. Albert Van Eerde
Mr. H. Van Slooten
Mr. Harry Vreeland
Mrs. John Chanavat
Miss Mabel Vicary
Mrs. Fred Vicary
Mrs. John R. Van Blarcom
Mr. O. Vanderzee
Mr. and Mrs. Walter Williams
Mr. Guion Whitaker
Miss Edith Welle
Mr. and Mrs. John Walton
Miss Anna Young
Miss Helma Leehrs
Mr. James Lappin
Mr. Ernest Bogert
Mrs. Ernest Bogert
Mrs. Geo. McCausland
Mrs. Arthur Bartsch
Mrs. John Eagleson
Mr. Narbert Foerster

MAIL FOLLOWING

I will join Hawthorne Public Library.

This is a 1920 request from the library committee asking for funds. The library was at this time supported by the contributions of 93 citizens who donated their money to maintain the building and purchase books. Dues were all of 25¢.

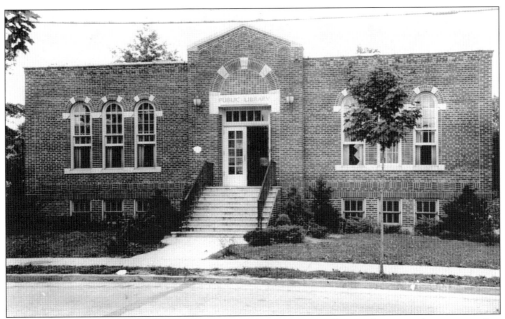

The library was built at its current location in 1931. Congressman George Seger was the main speaker at the dedication. He was also responsible for helping to get funding for the Post Office Block.

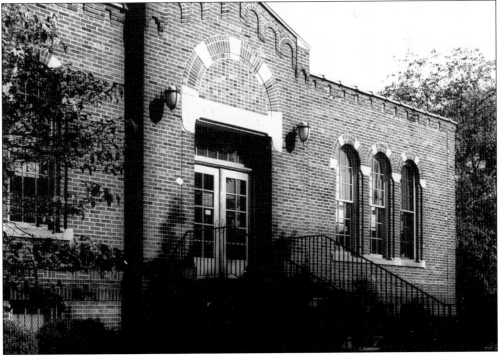

The building fund for the library was instituted in the 1920s, as a new facility was needed to house books that were then stored in the post office building as well as in the Lafayette Avenue municipal building. The library was paid off by the purchase of parcels of land. Lots on Lafayette Avenue and Grand Avenue were sold to raise the money. This photograph shows what the money paid for: the library, which was later named in honor of Mayor Louis Bay II.

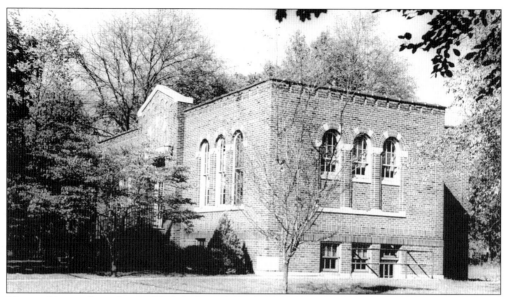

Many additions have been added to this side of the library over the last 30 years. The part of the building seen here is now the office of the director and staff. It also houses the books that are to be processed and released for use by the public. Today it is common to see teenagers congregating after school on the grass, which is now the walkway into the adult section of the library.

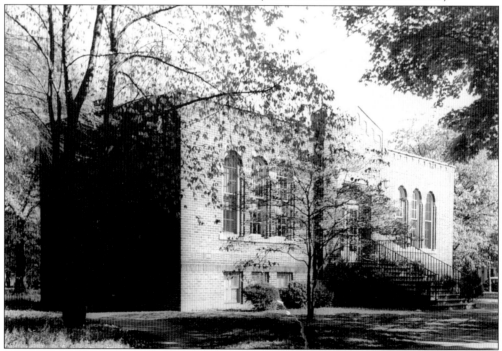

The angle of the library in this picture is unique because another addition to the library can be seen here today. In this 1930s photograph, however, the area on the left where the parking lot and community center are today is just a path cut through the grass and trees are scattered behind the building. Today most of the trees are gone and in their place is the William A. Monaghan Jr. Gallery, which exhibits works by local artists.

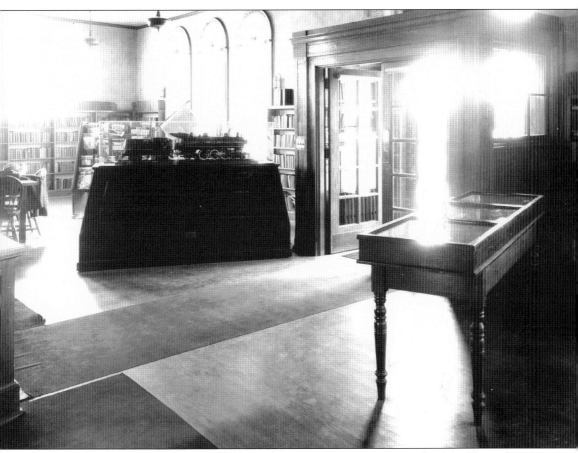

Taken in the 1930s, this photograph shows the interior of the opposite side of the library. It was part of the collection of Walter Lucas, longtime Hawthorne historian.

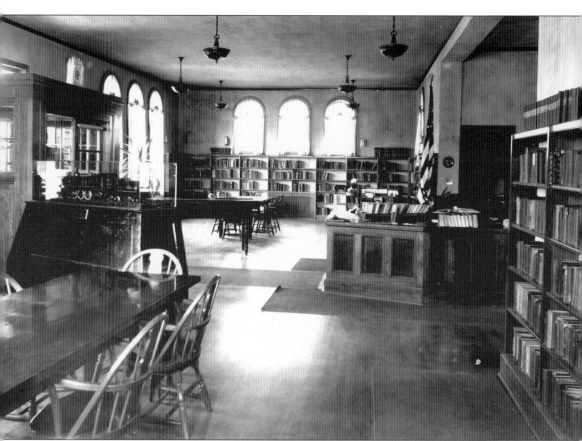

Probably taken on the same day as the interior view, this photograph is also from the collection of Walter Lucas. Note the display case (left), which was used to show the things that were brought to Hawthorne.

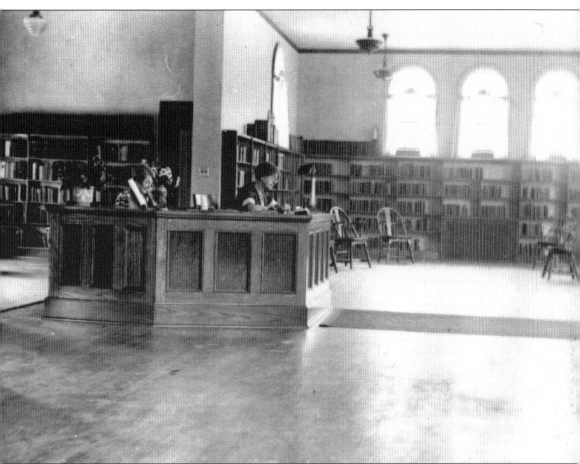

Harriet d'Archambaud works diligently behind the desk. She and an assistant were paid, but many teachers from the local schools worked at the library on a volunteer basis.

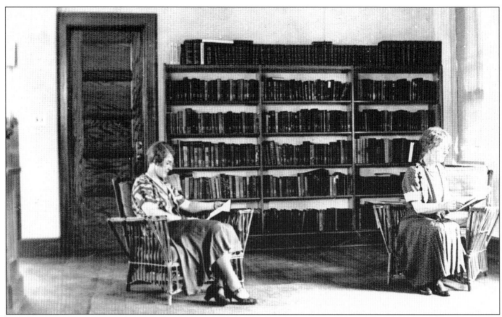

Two women read in front of a bookshelf at the library in 1930. Most of the bookshelves and furniture were donated by people from the local area and beyond.

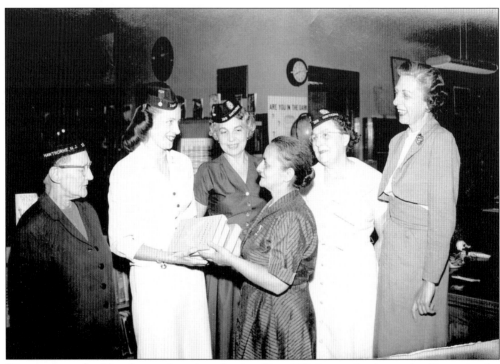

Women from the Hawthorne American Legion Post 199 donate books to the library in the late 1950s. The date of the photograph is a guess based on the book that can be seen over the shoulder of the woman on the left. The title is *Young Teens Talk It Over*, by Mary Beery, published by Whittlesey House, New York, in 1957.

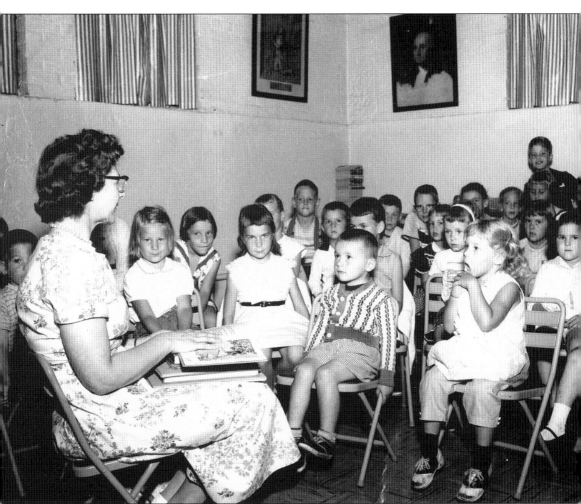

The benefits that the Hawthorne Library story times have had for children over the years can never be measured. Back in the 1940s, assistant-librarian Joan Doyle was the storyteller, just as the person in this photograph is.

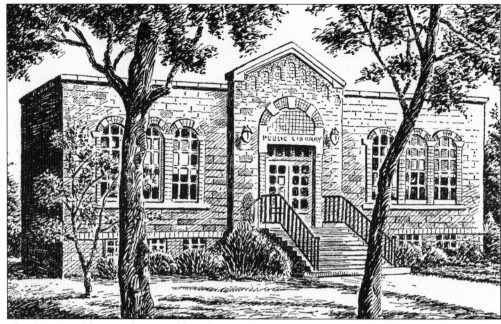

This drawing of the Hawthorne Public Library is from a 1958 invitation. The library board of trustees invited the townspeople to a ceremony presenting the Hawthorne Library as a gift to the borough. One source said, "It should be noted that the gift of the library is a monument to the trustees living and dead, who have devoted so much of their time and effort to build a better community."

The Board of Trustees

of the

Hawthorne Public Library Association

request the honor of your presence

at the

unveiling of a memorial to

Minnie B. Johns

on Sunday, the Fourth of October

at Four o'clock

at the Library, Hawthorne, New Jersey

This card is an invitation to remember former librarian Minnie Johns. As is seen in the next few photographs, she carried a special place in the hearts of the townspeople and a memorial was erected in the library in her honor.

In 1952, Minnie Johns passed away. A day and a display were held in her honor. An invitation was sent out, inviting townspeople to attend the memorial, seen here.

Townspeople gather to honor Minnie Johns, who devoted many years of service as librarian and the president of the library board.

Members of the library board of trustees are, from left to right, Elmer Bakelaar, Anita Grady, Walter R. Dewey, Grace Steinmetz (president of the board), Louis Bay II (mayor), Ethel Anderson, and Grace C. Bruening (library director). Missing from the photograph is school superintendent Dr. John B. Ingemi. State law requires the library to be managed by a seven-member board that includes the mayor and the school superintendent and five of their appointees. In 1957, the people of Hawthorne voted for the borough to take control of the library. Since the Trustees Association of the Hawthorne Public Library gave the town the ground, the building, and its contents, all at no cost, it was very much a gift.

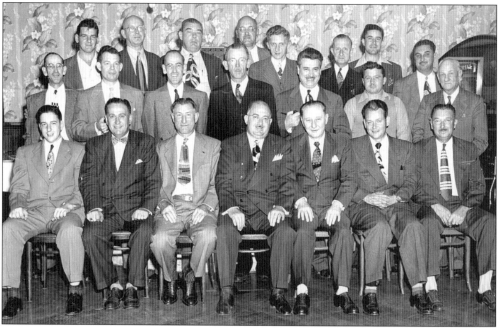

Mayor Louis Bay II (front row, center) was a member of the Hawthorne Gun Club. Incorporated in 1948, the club accepted persons over the age of 21 who were recommended by a member in good standing. It held a dance and dinner in the spring to honor new members and events like the annual junior rifle competition, a pre-Thanksgiving turkey shoot, a pre-Easter ham shoot, and an invitational competition in Civil War–style shooting.

FOR CONTINUED GOOD GOVERNMENT

IN THE BOROUGH OF HAWTHORNE

★★★★★★★★★★★★★★★★★★★★★★★★★★★★★★★★★★★ E L E C T ★★★★★★★★★★★★★★★★★★★★★★★★★★★★★★★★★★★

THESE MEN OF PROVEN ABILITY

ROBERT K. ROBERTSON	**WILLIAM E. FAIRHURST**	**LOUIS BAY, 2nd**
for the office of	for the office of	for the office of
Department of Revenue and Finance	Department of Public Improvements	Department of Public Safety

He is a member of the firm of The Paterson-Reed and Harness Company. He was formerly associated with the Francis McCully Investment House. He has served as Commissioner of Revenue and Finance in the Borough of Hawthorne since 1936, and as head of that department planned the refunding of Borough Bonds so that a savings of over $80,000 was realized. He is a graduate of the Paterson School System and the Phillips Business College.

He is a member of the Engineering Department of the Central Railroad of New Jersey. He has served six years on the Board of Education and was a member of the Hawthorne Sewer Advisory Board. He planned all the changes in the Water System of Hawthorne for the past six years, during which time he held the office of Commissioner of Public Improvements. He is a graduate Civil, Mining, Electrical and Mechanical Engineer of Lehigh University in Pennsylvania.

He is the Technical Advisor and Sales Manager for the A. H. Mathieu Chemical Co. He has served three years on our Board of Education and became President in 1942. He is an active member of Fire Co. No. 3 and has been for the past ten years. He is a member of the Board of Health. He was educated in Hawthorne and Central High School and attended Pratt Institute of Science and Technology in New York.

★★★

ELECTION DAY, TUESDAY, MAY 11th, 1943

Polls Open From 7 A. M. to 8 P. M.

Hawthorne Tax Rate: In 1936 - $4.86 In 1943 - 4.03 Keep the ball rolling

This is a campaign advertisement from the 1943 campaign of Louis Bay II. Bay ran with Robert K. Robertson and William Fairhurst. Robertson at the time was serving as the mayor. Three men were elected and one of the three was then chosen as mayor. Robertson was described as "a Finance man . . . an outstanding one." He paid off $1 million in bonds and reduced the tax rate by 81 percent. He served as the commissioner of the Department of Revenue and Finance.

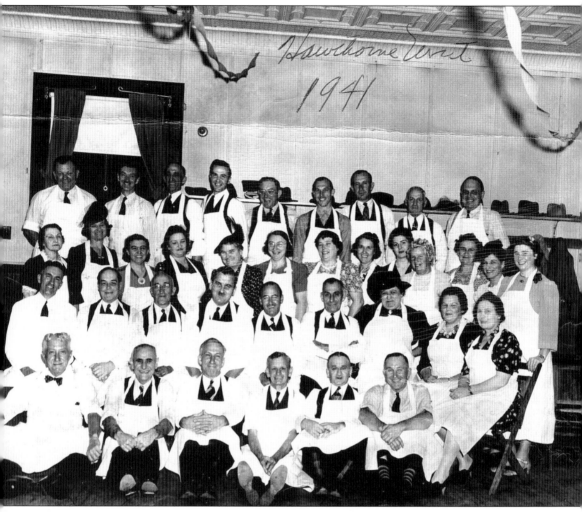

This group worked to honor Robert K. Robertson with a beefsteak dinner in 1941. From left to right are (first row) Rynier Speer, William Vallee, Henry Zumberge, James Boardman, Howard Glover, and Marinus Monday; (second row) commissioner William Fairhurst, commissioner Joseph Harrison, Mayor Robert Robertson, Raymond Rhodes, county treasurer Lloyd Marsh, Jacob Westerhoff, Ethel Garrison, Doris Zumberge, and Carrie Van Valkenburg; (third row) Nellie Hopper, Ruth Wright, Frances Block, Elsie Peia, Josephine Clark, Catherine Prince, Clara Hawthorne, Marion Tryon, Catherine Gloor, Ellen Sheppard, Addie Braen, Ruth Patton, and Lillian Rowland; (fourth row) Arthur Nelson, Fred Daw, Henry Meuche, Marvin Hanson, William Vandervliet, Sam Bloom, Adrian Meyer, Edward Latter, and Maurice Homer.

FOR CONTINUED GOOD GOVERNMENT
IN THE BOROUGH OF HAWTHORNE
=ELECT=
MEN OF PROVEN ABILITY

LOUIS BAY, 2nd
for the office of
Department of Public Safety

WILLIAM E. FAIRHURST
for the office of
Department of Public Improvements

JOHN L. TITUS
for the office of
Department of Revenue and Finance

He is the Technical Advisor and Sales Manager of the A. H. Mathieu Chemical Company. He has served three years with the Board of Education and became President in 1942. He has been an active member of Fire Company No. 3 for the past 14 years. He served as a member of the Board of Health and has held the office of Commissioner of Public Safety for the past four years. He was one of the founders of the Boys Club. He was educated in Hawthorne and Central High School and attended Pratt Institute of Science and Technology in New York.

He is Engineer to the Chief Executive of the Jersey Central Lines and is a licensed Professional Engineer. He has served six years on the Board of Education and was a member of the Hawthorne Sewer Advisory Board. He planned all the changes in the Water System of Hawthorne for the past ten years during which time he held the office of Commissioner of Public Improvements. He is a graduate Civil, Mining, Electrical and Mechanical Engineer of Leheigh University in Pennsylvania.

He is a Certified Public Accountant and a member of the faculty of Pace Institute, N. Y. C. A veteran of World War II., he served as a special agent for the Counter Intelligence Corps and auditor for the Manhattan Engineer District (Atomic Bomb Project). He has had ten years banking experience with the Chase National Bank, N. Y. C. He is a graduate of the Intelligence School and Pace Institute and he attended New York University and the American Institute of Banking.

Election Day, Tuesday, May 13, 1947
POLLS OPEN FROM 8 A. M. TO 9 P. M. DAYLIGHT SAVING TIME

HAWTHORNE TAX RATE: IN 1936—$4.86
IN 1947—$4.61

Hawthorne's government was based on a commission system. Three men were chosen to head the departments of Hawthorne, and one of those three was chosen as mayor. This is an advertisement for Louis Bay II, who ran for mayor and lasted well into the 1980s. This time Robert K. Robertson did not run with Bay and William Fairhurst. John L. Titus, a trained public accountant and World War II veteran was chosen. On March 31, 1947, an excerpt in the *Paterson Evening News* said, "A public official can't go wrong with being thrifty with the taxpayer's money and so it looks like Commissioners Louis Bay 2nd and William E. Fairhurst and their running mate, John L. Titus, will be returned to office in the Hawthorne Commissioners Election."

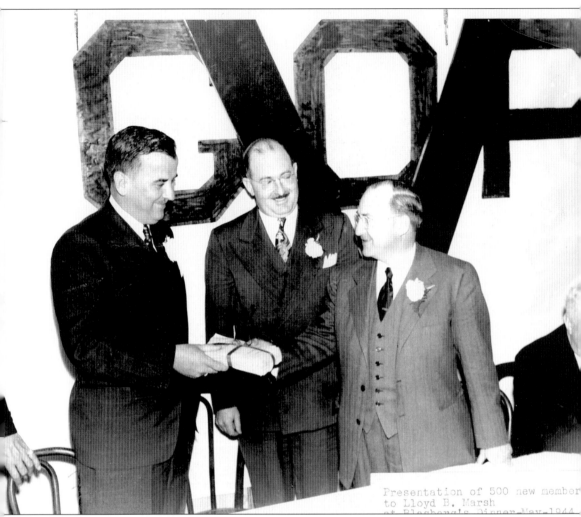

Presentation of 500 new member
to Lloyd B. Marsh
at Blasberg's Dinner May 1944

Raymond Rhodes (left) and Louis Bay II present Lloyd Marsh, the future secretary of state of New Jersey in 1945 under Gov. Alfred Driscoll, with 500 new members of the Republican party in 1944. The party was held at the Blasberg's hall in May of that year. The secretary of state of New Jersey is responsible for preserving the arts, history, and culture of the state. Marsh served as a Republican delegate to the Republican National Conventions. He also served as the chairman of the New Jersey State Republican party.

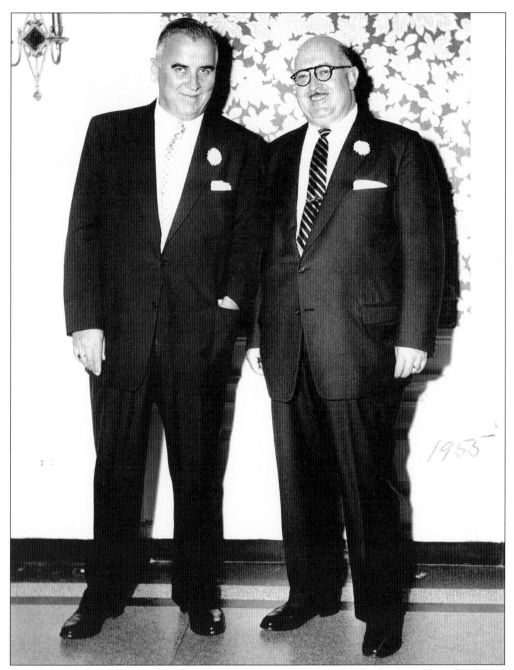

1955

Pictured in 1955, Raymond Rhodes (left) and Mayor Louis Bay II had a friendship that lasted for years. The younger brother of former mayor Arthur Rhodes, Raymond Rhodes owned the real estate agency in Hawthorne that still bears his name today. William Mearns, chairman of the Tercentenary Chairman Committee, described Rhodes as someone who "chatted in a friendly conversation with Queen Elizabeth, the Queen Mother of England, as she sailed up the Hudson." He recalls the "cryptic repartee" of former Pres. Harry Truman as well as conversations with Pres. Dwight D. Eisenhower, Richard Nixon, and others.

Hawthorne School No. 3, on Goffle Road, was at one time called Manchester School 11. The structure was built in 1885 and was later used as a police station. In 1936, it was destroyed by fire.

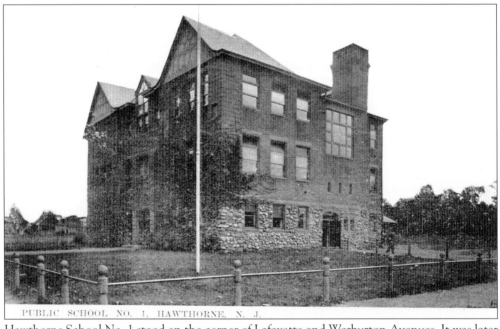

PUBLIC SCHOOL NO. 1, HAWTHORNE, N. J.

Hawthorne School No. 1 stood on the corner of Lafayette and Warburton Avenues. It was later named the Lafayette School and eventually came to be the Hawthorne Municipal Building. It was destroyed by fire in the 1970s.

Six

KNOWLEDGE AND EDUCATION

Malcolm Forbes, businessman and *Forbes Magazine* founder, once said, "Education's purpose is to replace an empty mind with an open one." Psychologist B. F. Skinner agreed with Forbes. In 1964, Skinner said, "Education is what survives when what has been learned has been forgotten."

Yet, Kim Spaccarotella asks in her video that details the history of the Hawthorne school system, "What makes a school successful?" In answer to her own question, she says, "I think it is the students and the teachers. They are the soul and heartbeat of a school; they define and develop the school's character; and as they overcome the obstacles that arise, the school grows stronger."

The story of Hawthorne and its schools is "the story of the trip from the town's past to the present, and the story will continue as long as the people of Hawthorne have the same dedication to make things better," Spaccarotella says.

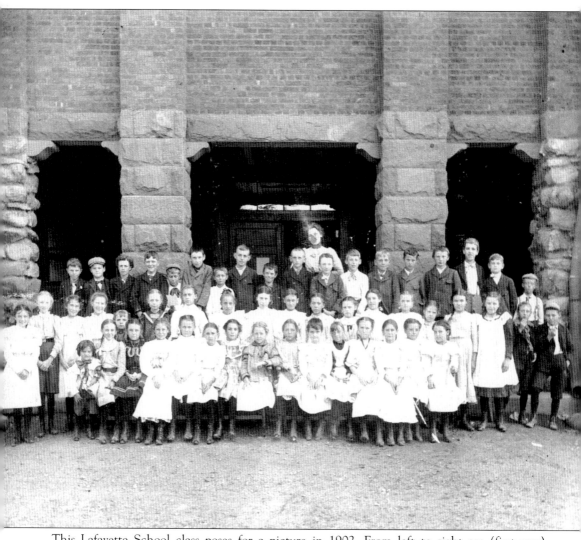

This Lafayette School class poses for a picture in 1902. From left to right are (first row) Euphiamea Hunter, Emily Hunter, Annie Snyder, Lizzie Foster, Rosie Shielze, Emma Prentice, Lettie Sackett, Rosetta Rhodes, unidentified, Mabel Vicary, Ruby Whittaker, Dora Spangenberg, Maggie Hoffman, Sadie Roat, and Ellen Knapp; (second row) Josie Eagleson, Elsie Post, Daisy Kinniard, Gladys McBain, Mary Hoffman, Clara Vrooman, Jessie Woodward, Alma Ehrlich, Freida Nelson, Nellie Camron, Annie Cannon, Estelle Burtt, Gertude Jones, Lucy Gayetty, Myrtle Williams, Mamie Williams, Nellie MacFarlan, James McGee, and Ernest Burtt; (third row) Bertie Van Allen, Arnold Benn, Edward Van Allen, Willie Cartwright, Arthur Holt, Stendard Buckout, Harry Anderson, Jacob Westerhoff, John Shea, Willie Beaton, Richard Evans, Edward Albertic, Grover Sprich, Bennie Sutton, Fred Hoffman, Leigh Prentice, Clyde Siney, and Charles Crabtree; (fourth row) E. Beatrice Young, faculty.

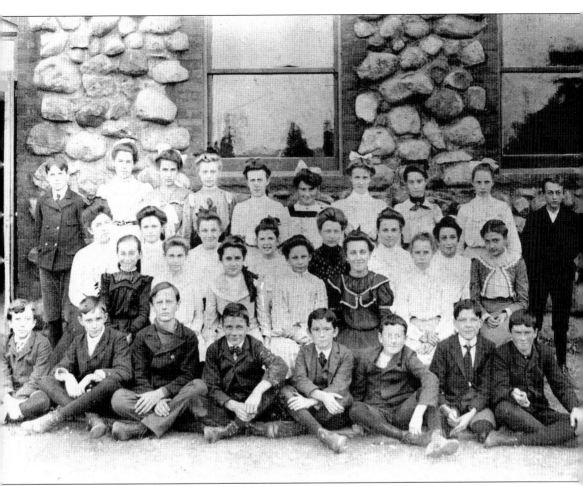

Many of the same children in the 1902 photograph appear in this 1904 Lafayette School class photograph. From left to right are (first row) Charles Demmwolfe, Grenelle Reid, George Sanner, Frank Hoelstra, Richard Siefert, William Laggner, Walter Jollie, and John Shea; (second row) Nellie Howard, Mary Waterman, Ethel Janes, Mirion Grenelle, Margurete Masker, and Florence Nelke; (third row) Sadie Roat, Estelle Burtt, Nellie MacFarlan, Eve Retgar, Rosetta Rhodes, Ellen Knapp, Mabel Vicary, and Dorothy Kuenaman; (fourth row) Richard Studt, Maude Kanouse, Louise Waterman, Clara Vrooman, Jennie Van DenBerg, Georgiana Cleveland, Mary Munson, Annie MacFarlan, and two unidentified students.

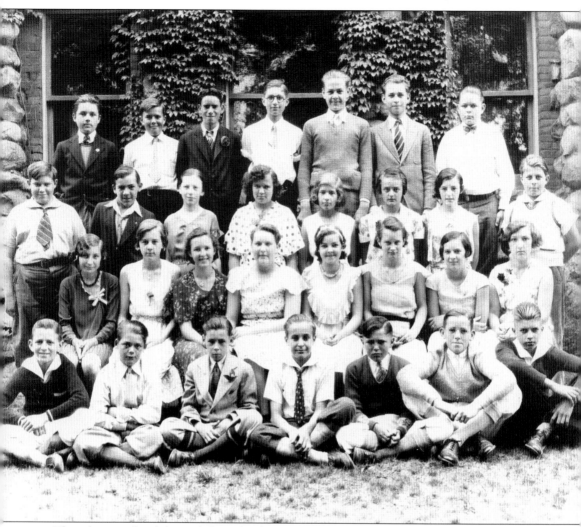

This photograph of the eighth-grade class at the Lafayette School was taken in June 1932. Identified are Donald Harvey Mather, Joseph Senior Burkhart, Arthur Donald Gill, Charles Lawrence Tschopp, Arthur Edwin Murray, Robert John Wright, James M. Planten, Josephine Cecelia Chayanne, Dorothy June Oakley, Margaret Evelyn Whitla, Jean Grey Anderson, Arlette Jewell Quass, Eleanor Anne Van Stone, Dorothy Keyser, John Henry Post, Charles Hill Meyers Jr., Helen Ethel Kay, Jeanne Rosamond Doane Van Der Clock, Ruth Van Dyk, Elizabeth G. Potterton, Mary Clare Sinn, Eugene M. Brink, Eugene Conrad Anderegg, Herbert Richard Wyatt, John Milsop, Otho Elmer Hooper Jr., Charles Ross Ernest, Arthur Bertam Van Houten Jr., and Frank Rea Jr. Alexander John Maitland was missing from the picture.

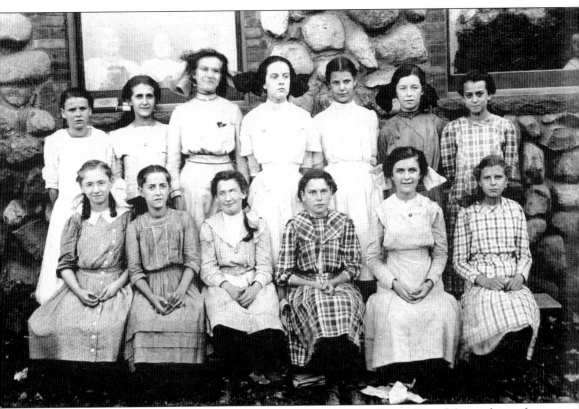

Among those in this picture, taken at the Lafayette School, is Bessie Bengel (second row, far right). "Ghostly images" of other students who snuck into view can be seen in the windows. This is another photograph in the collection that belonged to Betty Ann DeKnight.

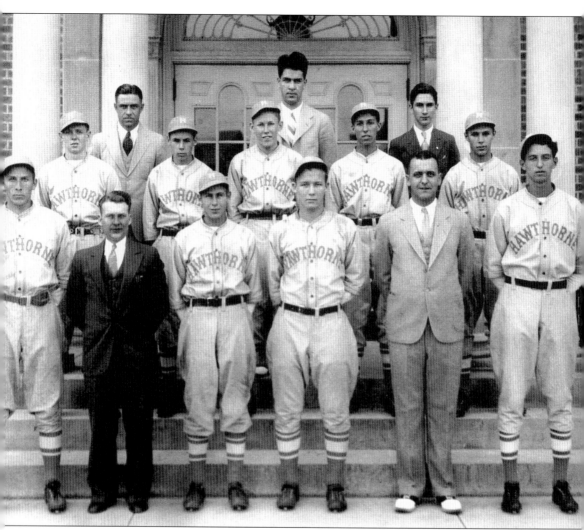

The 1935 Hawthorne High School baseball team was the Passaic County champion, with an 8-1 record. From left to right are (first row) shortstop Peter Yagodzinski, a senior; faculty member Frederick Trend; third baseman Herman Kuiken, a junior; catcher Albert Grefe, a senior; coach Allison King; and left fielder Vernon Morrow, a junior; (second row) pitcher Lawrence Williamson, a junior; center fielder Arthur Gill, a junior; second baseman John Rozema, a sophomore; right fielder Frankie Ackerman, a junior; and first baseman Mellor Gill, a senior; (third row) coach Seaman Gray; faculty member Charles Dueersema; and manager John Cooke. Missing from the photograph is pitcher Robert Jantzen, a sophomore.

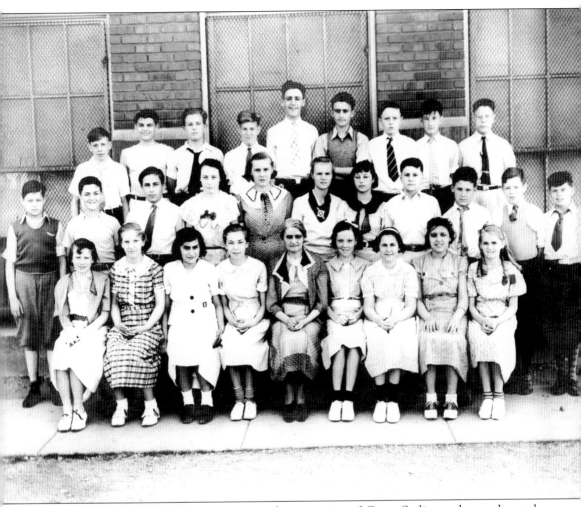

The three next photographs were once in the possession of Casey Styling and were donated to the Louis Bay II Public Library for this project. Unfortunately, many of the students remain unidentified. The same teacher is seen in all three photographs. Here, she is seated in the center of the first row. Beyond that, the photographs were taken at the Franklin School, on May Street, sometime between 1934 and 1936. The school itself was sold in the 1980s and was transformed into an apartment complex. The Hawthorne town pool is located on the other side of the fence.

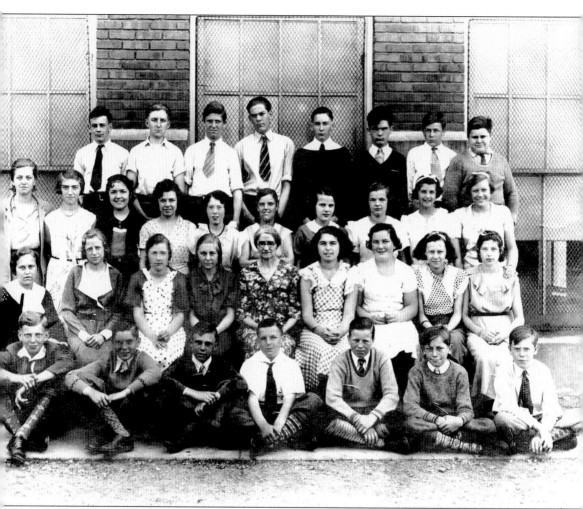

The land on which the school stands used to be part of the De Gray household. The De Grays were another old-time family that was here long before Hawthorne was even Manchester. The land was purchased for $1,000. In her video detailing the history of the Hawthorne school system, Kim Spaccarotella quoted 1912 sources saying that construction of the building began in 1910. The work was slow to finish. It was met with challenge after challenge, much of which centered around poor building materials and leaky windows. When the eight-room school opened, it had 156 students. William Van Stone was the first principal.

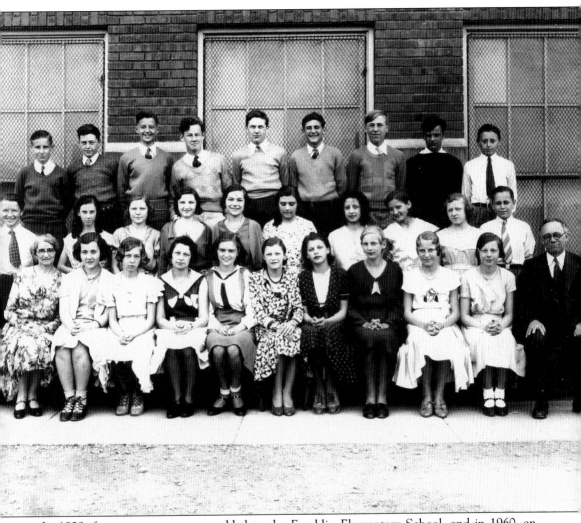

In 1928, four more rooms were added to the Franklin Elementary School, and in 1960, an all-purpose room to be used as a gymnasium and auditorium was added. By the 1960s, student enrollment had more than doubled to 375 students and classes were offered in art, music, industrial arts, home economics, physical education and health, reading, and speech. The Franklin School was graced with a Parent Teacher Organization that managed to raise money and donate most of the equipment it used. As Hawthorne's schools continued to change, the Franklin School closed in 1985 and was sold to a private company.

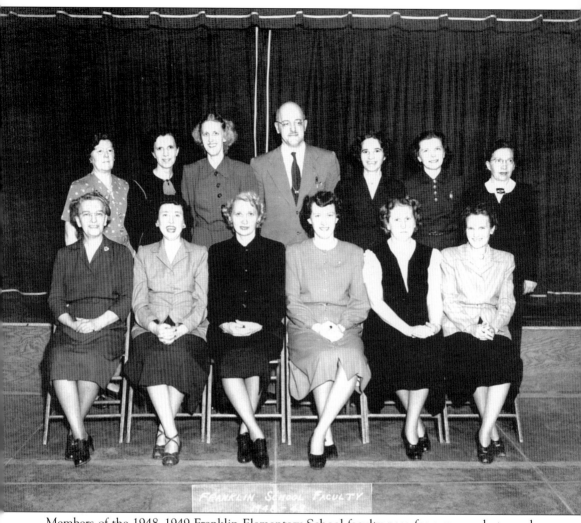

Members of the 1948–1949 Franklin Elementary School faculty pose for a group photograph. The picture was taken by the Wilkins Photo Studios. Some students have jokingly referred to picture time as one of the scariest next to the dreaded SATs.

Showing off the bulletin board behind them, students and their teacher at the Franklin Elementary School kneel to provide a clear view. This class of the mid-1950s was learning about animals.

The teacher steps out of the way to offer a better view of her class's handiwork on the bulletin board. Typical of most children, some of these students smile, some frown, some make faces, and some close their eyes as the light of the camera flashes.

With the students and children out of the way, the viewer can get a better look at the bulletin board. The drawings and hand-crafted cutouts reveal the circus theme about which the children were smiling earlier. This is probably the closest these children came to "running away to join the circus."

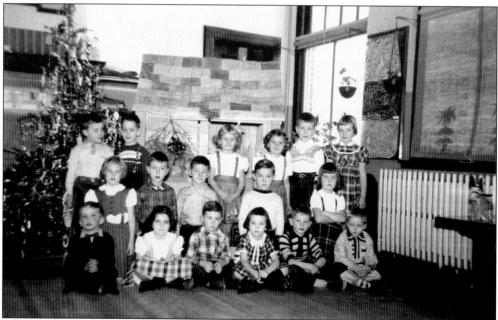

Students at Franklin Elementary School pose in front of their decorated tree in 1954. From left to right are (first row) Roger Kihm, Vilma Passaro, Russell Edwards, Brenda Quickley, Robert Mauldin, and Dennis Barker; (second row) Mary Shay, Bradley Floyd, James Wheater, Gary Woortman, and Lorraine Whitford; (third row) Stephen Wood, James Mearns, Norma Siemsen, Nancy Montano, Greg Drusdow, and Barbara Van Slooten.

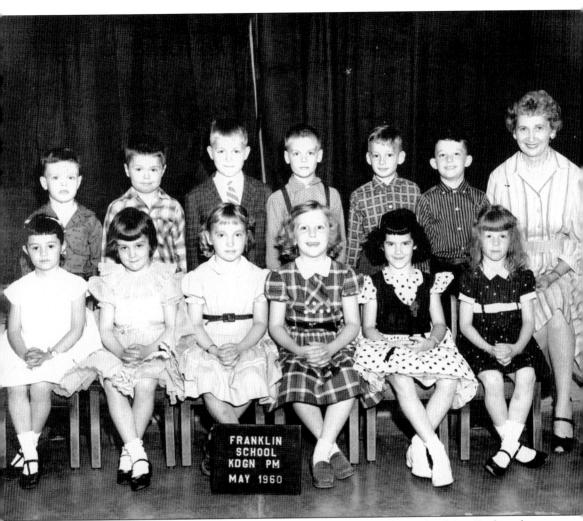

The afternoon kindergarten class poses for a school photograph with teacher Mary Rodts, who taught at Franklin Elementary School for over 30 years. Mary Rodts kept photographs of her kindergarten classes in her Diamond Bridge Avenue home. From left to right are (first row) Linda Badagliacca, Betty Jane Skillen, Joyce Corwith, Gay Gerritsen, Joan Goble, and Randy Smith; (second row) Robert Swankie, William Shallcross, Henry Kiefte, Daniel Palko, Scott Garside, and Gary Shannon.

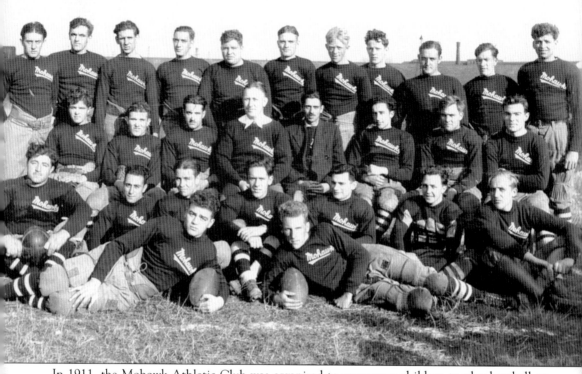

In 1911, the Mohawk Athletic Club was organized to encourage children to play baseball or softball. Later, the Mohawks supported soccer and basketball teams. In the middle 1950s, the club went on to start the Hawthorne Little League. This photograph was donated by Mrs. Thomas Pritchard of Wayne.

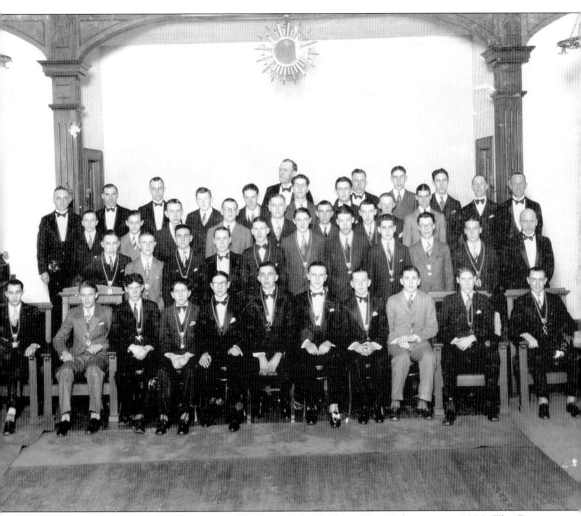

The new members of the Hawthorne Chapter of the Order of De Molay pose in 1928. The De Molay, a division of the Masons for teens and youths, was started sometime between the late 1920s to the early 1930s. Dr. Claude Van Stone described the purpose of the De Molay as "the teaching of clean and upright living, by inculcating and practicing the virtues of comradeship, reverence, love of parents, patriotism, courtesy, cleanliness and fidelity. Its supreme effort is to create leaders and to develop character, its slogan is "No De Molay shall fail as a citizen, as a leader, or as a man." The De Molay chapter ended, however, when the membership of the Hawthorne Masonic Lodge dropped, forcing it to combine with Masons from nearby towns.

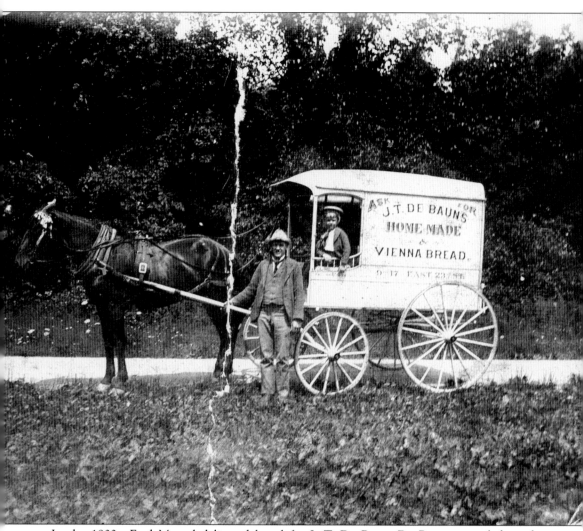

In the 1900s, Fred Mensel delivered bread for J. T. De Baun. De Baun was a baker who employed delivery men. Mensel traveled all over Hawthorne with his horse-drawn wagon. The Hawthorne Bakery route went from the Riverside area of Paterson to Lincoln Avenue to Van Winkle Avenue across to Lafayette Avenue and back to Paterson. Here, Mensel stops to pose for a photograph with his five-year-old son John.

Seven

INDUSTRY AND TRAVEL

It is all about industry. Though rich in farmland, Hawthorne's industries were many. When it was first settled, the area was a leading producer of farms that sold what was grown at the local markets. Before the Revolutionary War, a wampum factory was made to produce currency for the Native Americans that fought with England during the French and Indian War. As time progressed, sawmills were built to cut the lumber from the trees that were taken down to make room for farmland.

Judge John Van Winkle had a gristmill in front of his home, and according to some sources, he did much of the milling work in the local area. During the Civil War, several of the mills provided blankets for the Union army.

After Hawthorne was incorporated in 1898, the farmland in the area began to disappear as houses went up. The population of Hawthorne rose from a mere 700 people to 2,500. To quote the 50th anniversary book, "Industry saw the possibilities of development." It was not too long after that the silk dyeing and rubber factories moved into town. With the railroad booming and municipalities like Paterson, New York City, and Jersey City growing, it was only a matter of time before Hawthorne opened its doors to attract more commercial enterprises.

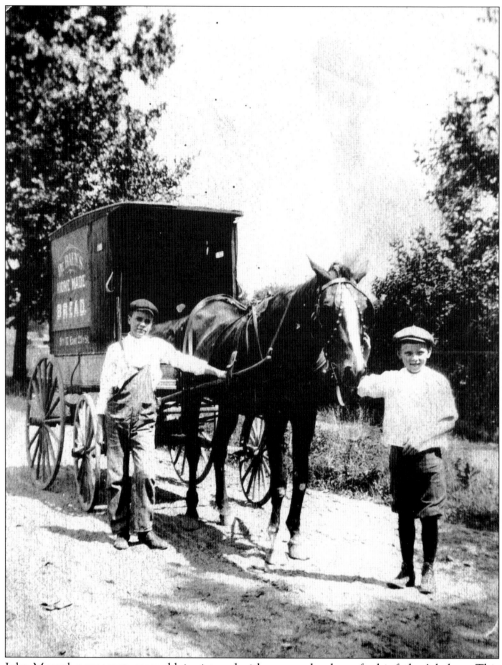

John Mensel, now seven years old, is pictured with a man who drove for his father's bakery. This photograph was owned by his sister Florence Heyns.

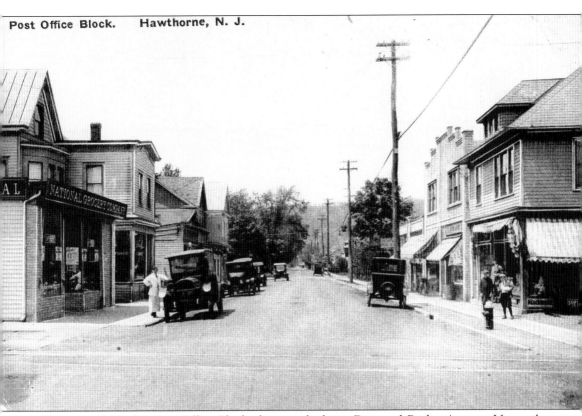

Taken in 1916, this Post Office Block photograph shows Diamond Bridge Avenue. Up until the middle of the 1860s, the mail was carried by stagecoach or by a rider on horseback. That changed later when the railroad came to town.

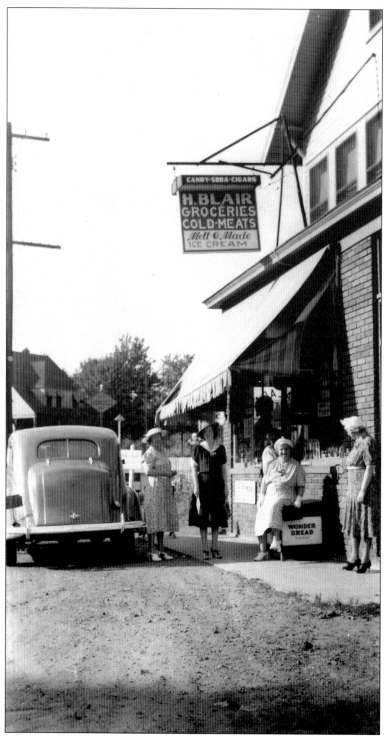

This store on Diamond Bridge Avenue was once owned by Laura and Henry Blair. The Blairs owned several stores in town. These women are stopping to enjoy themselves after a brief car trip.

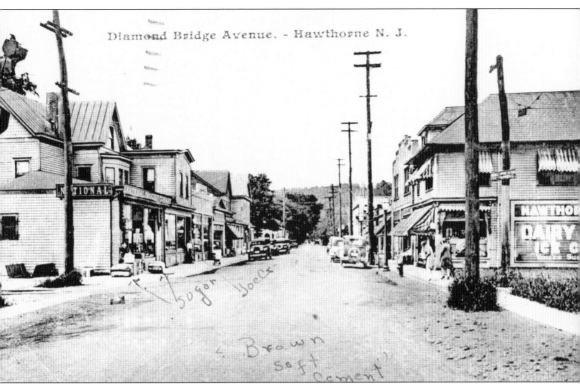

This view of Diamond Bridge Avenue was taken from a different angle. Someone has written "sugar" on the left and "brown soft cement" in the foreground. What is not clearly identified is a tailor shop that belonged to Eugene Bigoth. The store specialized in "Ladies' and Gents' Tailor Cleaning and Pressing." The Vanderzee brothers had a contracting business at the corner of Lafayette and Diamond Bridge Avenues. John Hughes had a drugstore named "A High Class Pharmacy." H. Bang owned a carpentry shop on Diamond Bridge Avenue and promised "estimates cheerfully given." A 1915 advertisement asked people interested in buying a home to apply to Robert H. Patton at 297 Diamond Bridge Avenue and for further questions, contact him at 3356-R, his telephone number.

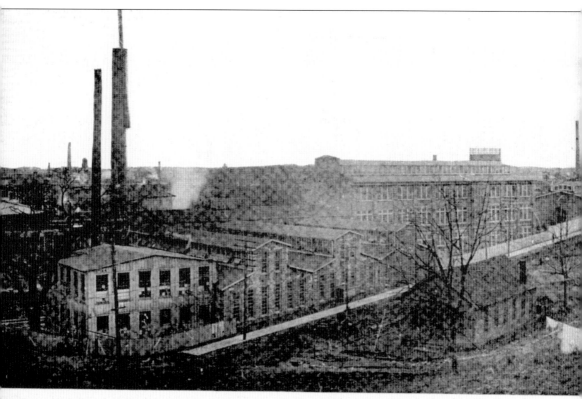

MERICAN SILK DYEING & FINISHING CO., HAWTHORNE, N. J.

William and Thomas Arnold were born in County Tyrone, Ireland, in the early 1860s. In 1891, they bought the Hawthorne Mills of the Ashley and Bailey Silk Company, located between North Eighth Street and Mohawk Avenue on Westervelt Avenue. They bought the plant that had been sold by Claude Geppo in 1888 from William Ryle.

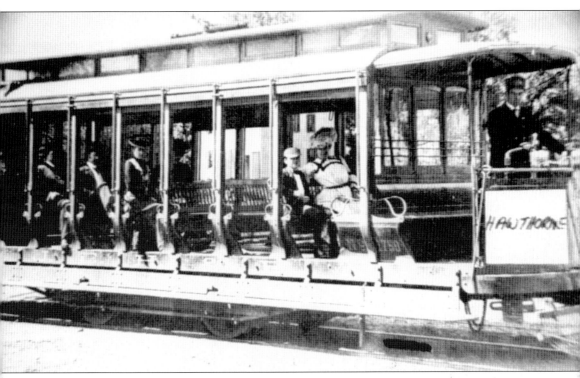

In an interview with *Main Street Magazine*, Mayor Louis Bay II recalled the trolley coming into town and following the route back into Paterson. The route began at Belle Avenue in Paterson went along Goffle Road then on Wagaraw Road in Hawthorne. There, it went north on Lincoln Avenue and switched to Grand Avenue, which traveled to Fourth Avenue on to Rock Road. In 1915, its route included Ridgewood and Midland Park.

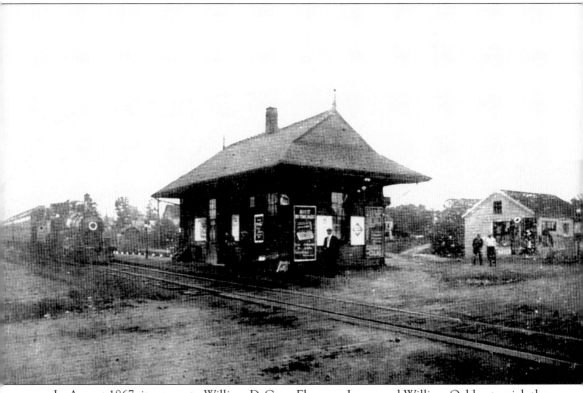

In August 1867, it was up to William DeGray, Ebenezer Janes, and William Oakley to pick the spot where the train station would be located. They met with Erie Railroad officials, and the station came into being.

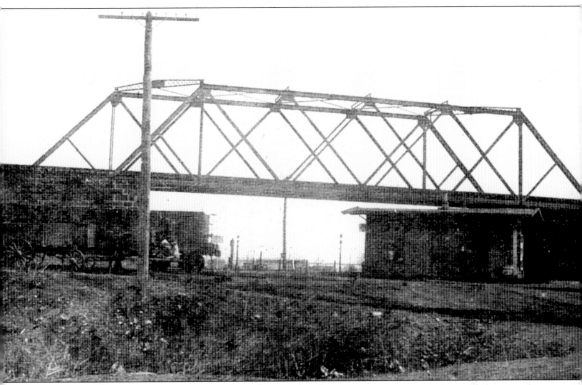

The New York, Susquehanna and Western Rail Road bridge was built in 1865. It was constructed with heavy wood timbers and formed a diamond shape. Later this diamond-shaped timber bridge led to a new name for Janes Lane.

At this Holiday Season
We express to You our appreciation
of past favors and wish you a
Happy Christmas
and a Prosperous New Year.
Community Service Station,
Van Winkle and Lafayette Ave., Hawthorne, N. J.

Today, on Lafayette Avenue across from Augie's Barbershop, the Community Service Station is still in the same family it has been for decades. The gas station, on the corner of Van Winkle Avenue, sent out photographs wishing customers and friends happy holidays.

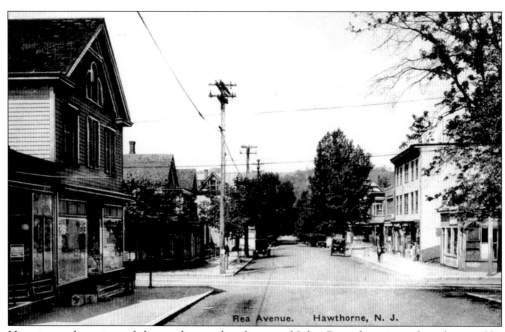

Rea Avenue. Hawthorne, N. J.

Here is another view of the road named in honor of John Rea, the minstrel performer. His family stayed in town long after his death. In fact, old photographs of his grandson were found amongst the school pictures.

Eight

FROM THE ROAD

At the end of the time travel movie *Back to the Future*, Dr. Emmett Brown (played by Christopher Lloyd) says to Marty McFly (Michael J. Fox), "Roads. Where we're going, we don't need any roads."

Well, Hawthorne cannot say the same thing. Hawthorne needed its roads. And as is true across the country, most of the roads were initially Native American trails—in Hawthorne's case, those of the Lenapes. European settlers later used these trails for horses, wagons, and carriages. And much later, when the automobile became popular in the early 1900s, many of the old trails were paved.

Interestingly, Lafayette Avenue came to be as a result of a toll that was set up in front of the Van Winkle farm on Godwinville Road (now Goffle Road). Farmers did not wish to pay to use the road, so they crossed through the cornfields. When Hawthorne officially became a town, the name of that crossing was changed to Lafayette Avenue.

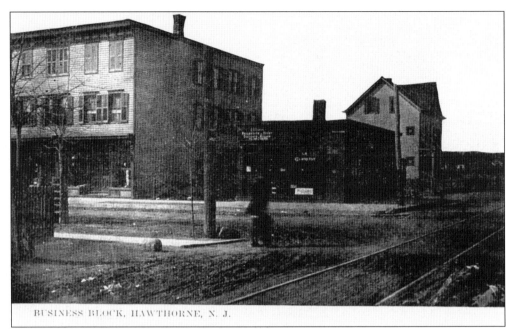

BUSINESS BLOCK, HAWTHORNE, N. J.

In 1930, the Diamond Bridge Avenue Association celebrated the street's pavement with a concert performed by a group of local firemen. Flags and colored lights decorated the streets, and several of the local businesses offered free souvenirs for the occasion.

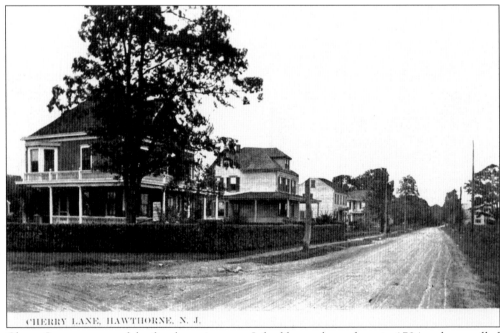

CHERRY LANE, HAWTHORNE, N. J.

Cherry Lane was one of the first lanes in town. It had been planned out in 1794 and was called Goetchus Avenue before becoming Cherry Lane (because of the cherry trees that lined either side of the highway). In the first half of the 20th century, it was changed to Lincoln Avenue.

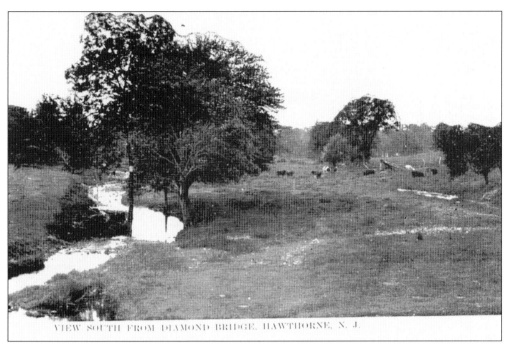

VIEW SOUTH FROM DIAMOND BRIDGE, HAWTHORNE, N. J.

This view of Diamond Bridge Avenue, with cows grazing in the background, shows what Hawthorne was: farmland for mile and miles. It was along this road that some of Hawthorne's first commuters settled after the Civil War.

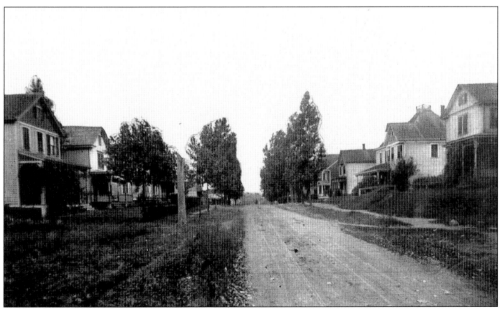

Betty Ann DeKnight tells a story about how her great-grandparents built the house (second on the right) after they moved up from North Bergen. Isabelle Lozier, Betty Ann's great-grandmother, would send one of the children up to the landing on the top of the house (which can be seen in this photograph). They would keep an eye out for their father, who worked at one of the local mills. The child would then call down and say their father was coming home for lunch.

This postcard was sent to Mrs. Howard Phillips in Marietta, Ohio. The writer of the card was visiting her family. The postcard, dated October 1948, said, "Hope everyone is okay. I got here 2:30 p.m. [on] Monday [and] everyone was glad to see me, and [they] are [doing] about as usual. [I] had a nice train, [but I] haven't been down to Paterson yet. Don't look for me til you see me. They want me to stay 2 weeks. [I] hope Dad [is] okay. [The] weather is fine [and there is a] fire in furnace. Bye-bye. Mother."

It was a meeting of the mayors. Members of the mayor and council celebrated Hawthorne's centennial by reenacting the night at Nelke's Bar when seven men turned a section of Manchester into Hawthorne. This photograph, taken by Judy Magna, shows former mayor Fred Criscitelli portraying Hawthorne's first mayor, Sylvester Utter, along with the borough's longest-sitting mayor, Louis Bay II (right).

ACKNOWLEDGMENTS

It is almost cliche for writers to say, "This book is not a solo work but a collaboration," and it is. There are so many people who have helped make this book a reality and they will forever be in my gratitude.

First, the project would not have even been brought to my attention without the help of writer and fellow Hawthorne resident Theresa Foy DiGeronimo.

Second, Tom Frawley and the rest of the librarians of the Louis Bay II Public Library in Hawthorne were kind enough to lend me photographs for this project.

I would also like to thank former editor of the *Shopper News* Rebecca Koeting, for giving me the first opportunity to write a story about the deaths of Judge John and Jane Van Winkle which really gave me a taste of Hawthorne's amazing history.

I would also like to thank historian, writer, novelist, and speaker Linda Zimmermann (not only for the Foreword) and Albert Stampone, editor of *Main Street* magazine, whose friendship and constant encouragement played a part in this book.

I would also like to thank Henry Tuttman, the current owner of the Van Winkle home, who has helped in my quest for the Van Winkles and Manchester-Hawthorne history.

Also, thanks go to my colleagues and coworkers at the North Jersey Media Group, specifically *Pascack Valley Community Life* in Westwood, and the *Community News/Gazette* in Fair Lawn.

I also would like to thank author Edward Smyk, Mary Jane Proctor, and the rest of the Passaic County Historical Society at Lambert Castle in West Paterson for the help provided for this book.

This could not have been completed without the help of Denise Keegan of Cliffside Park. Simply put, it was her friendship and technical know-how that helped complete the manuscript.

Also a big thank-you goes to other Arcadia authors such as Elaine B. Winshell, coauthor of Arcadia's Fair Lawn book, who took time out of her volunteer work and teaching to offer me advice, and Howard Lanza, author of *Garfield* and his own *Gateway to the Past* (a guide to Cedar Lawn Cemetery) for his advice and his love of history.

Of course, this book would not be here had it not been for the photographs provided by the following people: Albert DiNicola; Barbara Crowley; Edna Hascup of Margate, Florida; Sylvester Utter's grandson and his wife, Donald and Gertrude Gray; the friends of Thomas Malcolm, Grace DeKnight and her daughter in law Betty Ann; Hawthorne Gospel Church's Pastor Howard Van Dyk and Linda Hanowitz; Judy Magna and her video *Hawthorne's Journey to its Centennial* were both valuable resources; Kim Spaccarotella, her family, and her video the *History of Hawthorne's Schools* were valuable resources, as well; Lois Stammer; the late Mayor Louis Bay II and his daughter Barbara Donahue; archaeologist and writer Edward Lenik; Al LaBarre for the map of North Paterson; Richard Soderbeck, American LaFrance fire engine restorer in Jackson, Michigan; Wesley Dunn of Lancaster, Pennsylvania, and James Remeter of Oklahoma; Mary Krugman of Montclair; Bonnie Faber and John Lasz of LAN Associates in Midland Park; Connie Fink of Illinois; Brian and Tracey Galloway Gaehring; William and Joan Patterson; Patricia Florence; Alyssa Barkenbush; Hawthorne police chief Martin Boyd, and the honorable mayor of Hawthorne Fred Criscitelli.

Also, I know for a fact that this book would not even be here today had it not been for the encouragement of the Northern New Jersey Christian Writer's Group and their prayers, so it is with a thank you, I also share this book with the newspaper reporter Chris Sagona and Louise DuMont author and speaker.

And of course this book would not even be here today had it not been for editor Pam O'Neil, who consistently allowed me to bounce ideas off of her and helped me keep things consistent.

Finally, I would like to thank members of my family: parents Don and Jean Smith, my brother David, my in-laws Donald and Karen Holmes, Michael Holmes, and my grandparents-in-law Tunis and Garberdina Nywening.

And of course, thanks go to my wife, Laura, whose love and support always brings me back from looking into the past to looking ahead to the future.

BIBLIOGRAPHY

Bailey, Rosalie Fellows. *Pre-Revolutionary Dutch Houses and Families in Northern New Jersey and Southern New York*. New York: Dover Publications, 1968 (Reprint of 1936 edition).

Clayton, Woodford W. *History of Bergen and Passaic Counties*. Philadelphia: Everts & Peck, 1882.

Hawthorne, New Jersey. Borough *of Hawthorne, New Jersey: 50th Anniversary Souvenir Book 1898–1948*, published in 1948.

Hawthorne, New Jersey. *Hawthorne Tercentenary Souvenir Book*, published in 1964.

Hawthorne, New Jersey. *Borough of Hawthorne, New Jersey: 75th Anniversary Souvenir Book 1898–1973* , published in 1973.

Heusser, Albert Henry. *The History of the Silk Dyeing Industry in the United States*. Paterson, NJ: Silk Publishing Company, 1927.

Krugman, Mary Delaney. Goffle Brook Park Historic District. Nomination to the National Register of Historic Places, January 2002 (Revised March 2002). Prepared for Please Save Our Parkland Committee, Hawthorne, New Jersey by Mary Delaney Krugman Associates, Montclair, NJ.

Krugman, Mary Delaney. The John W. Rea House. Nomination to the National Register of Historic Places, April 20, 1999. Prepared for Please Save Our Parkland Committee, Hawthorne, New Jersey by Mary Delaney Krugman Associates, Montclair, NJ.

Lenik, Edward J. *Indians in the Ramapos*. New Jersey, The North Jersey Highlands Historical Society, 1999.

Magna, Judy. *Hawthorne's Journey to its Centennial*. Hawthorne, New Jersey. A video produced by the Louis Bay II Library, 1999.

Spaccarotella, Kim. *The History of Hawthorne Schools*. Hawthorne, New Jersey. A video created and produced by Kim Spaccarotella, 1999.

ABOUT THE AUTHOR

Though born in Portsmouth, Virginia, Don Everett Smith Jr. was raised in Bergenfield and educated at the Christian School in Hawthorne. It was here that his history teacher Daniel Brown said to him, "Without writing we would not have a history or history books." For the next several years, Smith pursued a love of writing, history, and comic books. After marrying Laura Holmes of Wyckoff, the couple settled down in Hawthorne with their cats; Bobby, Merlin, and Banjo. When the opportunity to write *Hawthorne* was presented, Smith jumped at the chance to work on a book about his town. *Hawthorne* is his first book. He has written for *Main Street Magazine*, *Pascack Valley Community Life*, and the *Shopper News* and is employed as a reporter for the *Gazette* and *Community News* in Fair Lawn. He is working on his first novel and a screenplay or two. His work has also appeared in *Renaissance* magazine, the *Writer's Post Journal*, and *Youth Worker* magazine.